IMAGES
of America

EARLY TOURISM
IN WESTERN
NORTH CAROLINA

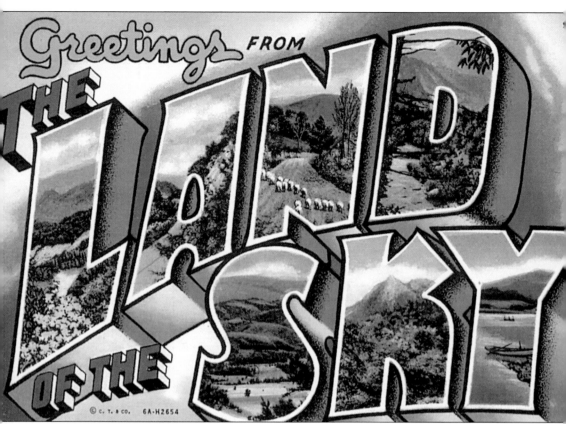

© C. T. & CO. 6A-H2654

THE LAND OF THE SKY. Used as a promotional theme for tourism since the 19th century, Land of the Sky refers to western North Carolina's beautiful high country mountain region and its many popular attractions. Journeying from Murphy in the south to Boone in the north, travelers discover the Great Smoky Mountains National Park, the Cherokee Indian Reservation, Biltmore Estate, the city of Asheville, Mount Mitchell, the Blue Ridge Parkway, Grandfather Mountain, Linville Caverns, Chimney Rock Park, the Blowing Rock, and more unique places and scenic wonders to visit. (Asheville Post Card Company.)

IMAGES
of America

EARLY TOURISM
IN WESTERN
NORTH CAROLINA

Stephen C. Compton

ARCADIA
PUBLISHING

Arcadia Publishing
Charleston, South Carolina

Printed in the United States of America

Library of Congress Catalog Card Number: 2003115042

For all general information contact Arcadia Publishing at:
Telephone 843-853-2070
Fax 843-853-0044
E-mail sales@arcadiapublishing.com
For customer service and orders:
Toll-Free 1-888-313-2665

Visit us on the Internet at www.arcadiapublishing.com

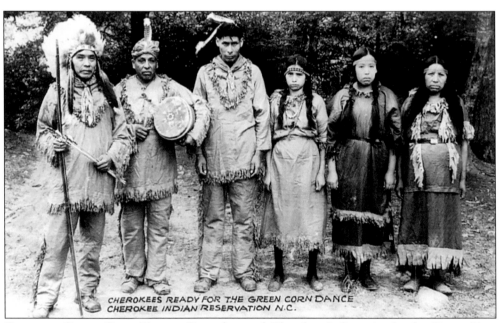

CHEROKEE GREEN CORN DANCE. One of several Cherokee Indian rituals, the Green Corn Dance celebrates the presentation of ripe corn to the village by Cherokee women, for whom planting and harvesting is a traditional responsibility. The Qualla Boundary of the Eastern Band of Cherokee Indians is located in the Great Smoky Mountains, including parts of Swain, Jackson, and Haywood Counties. (Cline Photo.)

CONTENTS

Acknowledgments

The images in this book are a reminder to me of all that I love about western North Carolina's people and places. Although I am a native of the rolling hills and flatlands of the Piedmont of North Carolina, I have since my boyhood had a special love for the mountain region of my home state. My grandmother, Carrie McDade Compton, was of Scots descent. The wife of a tobacco farmer, she had only a few occasions to leave home and fields for a vacation. Her favorite place to visit on these rare excursions was the Blue Ridge Mountain range. I have wondered if her love for the mountains of North Carolina were not somehow a genetically ingrained memory of her family's roots in the highlands of Scotland. Perhaps some of that memory is in my soul as well.

However I came to have this passion for western North Carolina, I am truly grateful to the people who have caused that love to grow strong in me. I am especially grateful to the many mountaineer friends I have come to know whose lives and love for the land of the Appalachians are what this book is all about. I am equally appreciative of my two sons, Matthew and Clay, who have tramped with me along trails, streams, and rivers to see the most remote places in this region sometimes called "Land of the Sky."

Since all of the images shown in this book but one (courtesy of Arthur Baer) come from my personal collection, I have only the photographers and publishers who made them and the dealers who sold them to me to thank for helping put together this documentation of a great region of the United States. Though I never knew him or his photographers, I am truly indebted to W.M. Cline of Chattanooga, whose photographic studio so thoroughly documented the people and places of western North Carolina. Throughout this project my wife, Camille, has been my best cheerleader. I do believe she is more excited than me about its publication. The book would have been neither started nor finished if it were not for her. I owe a special word of thanks to Maggie Tiller of Arcadia Publishing for her enthusiastic assistance in the production of this book.

Finally, I dedicate this book to my grandmother, Carrie McDade Compton.

INTRODUCTION

The state of North Carolina is divided into three regions: the Coastal Plain, the Piedmont, and the Mountains. At times called the Variety Vacationland, North Carolina lives up to its reputation when one considers that in a long day's journey a person can travel west by car from the Outer Banks at the Atlantic Ocean, through the rolling hills of the Piedmont, and into the highest mountain range east of the Rocky Mountains. Tourist attractions—scenic, historic, and fabricated alike—give visitors much to choose from when seeking refuge from work and the routines of home life.

Western North Carolina has for a very long time been a mecca for tourists. Its greatest attractions have always been its climate and natural scenic beauty. Following the Civil War, some resort hotels were built in the mountain region, and wealthy families constructed summer homes in the cooler climes of the high country. Resort communities were developed, like Linville near Grandfather Mountain and Highlands in Macon County. The incursion of railroads into the once inaccessible reaches of the mountains opened up the area to growing numbers of outsiders. Once good roads were constructed, motor vehicle access became possible for an increasingly large number of people.

Today, tourism is one of the state's largest industries. Ranked only behind five other states, including California and Florida, North Carolina hosted more than 44 million visitors in 2002. In the same year, four of the top six attractions visited in North Carolina were found in the mountain region, with over 15 million motorists traveling the North Carolina section of the Blue Ridge Parkway and more than 9 million visitors coming to the Great Smoky Mountains National Park (Source: N.C. Department of Commerce).

Early Tourism in Western North Carolina looks at many aspects of mountain area tourism. Foremost are the natural scenic places like those found in the vast wilderness of the Great Smoky Mountain National Park and other wild locales, such as Mount Mitchell, Grandfather Mountain, Chimney Rock, Linville Falls, Linville Gorge, and the many wonderful views spotted along the Blue Ridge Parkway. Waterfalls, rivers, and coldwater streams are ubiquitous and add to the sense of adventure in exploring the mountains. They are like icing on a cake for tourists whose interests are drawn to the natural beauty of the mountains. There are the towns and villages and farms nestled in valleys and coves throughout the region—places like Andrews, Murphy, Highlands, Tryon, and Valle Crucis—and the wonderful people who inhabit them. Tourists require services such as places to stay, eat, service their cars, and shop. So *Early Tourism in Western North Carolina* identifies numerous inns, hotels, motels, lodges, and camps that sprang up all over the mountain region in the first half of the 20th century.

To satisfy the demand for vacation souvenirs, enterprising mountain people developed a thriving handicraft business, making everything from corn shuck dolls to sophisticated hand-carved furniture. These people and the places where they trained and worked, like the John C.

Campbell Folk School and Penland School of Handicrafts, are considered. No western North Carolina vacation is complete without a visit to the Qualla Boundary, home of the Eastern Band of the Cherokee Indians. Engineered and constructed scenic wonders, like the many dams and lakes made to produce hydroelectric power and to control flooding, enhance the natural beauty of the region. Fontana Dam, built in the early 1940s, continues today to draw visitors from all over because of its massive concrete face and the beautiful lake formed by the waters it contains. Finally, *Early Tourism in Western North Carolina* visits several tourist attractions developed specifically to appeal to post–World War II adults and their young baby boomer children. In particular, places like Blowing Rock's Tweetsie Railroad and Beech Mountain's Land of Oz are described.

Although today the Cloudland Hotel no longer sits perched on the shoulder of Roan Mountain, and the Yellow Brick Road no longer guides children through the Land of Oz, the many wonders, sights, and attractions found in western North Carolina beckon to travelers seeking vacations filled with beauty, adventure, history, and the most wonderful people to be found anywhere.

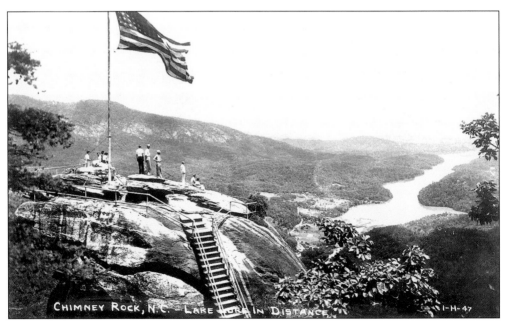

CHIMNEY ROCK. A granite monolith rising some 225 feet above scenic Lake Lure, Chimney Rock is located in Rutherford County, peaking at 1,050 feet above sea level. First opened in 1885, today's Chimney Rock Park is one of North Carolina's oldest developed tourist attractions. (Cline Photo.)

One

THE GREAT
SMOKY MOUNTAINS

One of the largest and most diverse wilderness environments in the United States, the Great Smoky Mountains National Park hosts millions of visitors each year. Its more than one-half million acres of mostly forested mountain land were once part of the Cherokee Indian homeland, and today the tribe lives on their Qualla Boundary land nestled against this majestic terrain of ancient high peaks, waterfalls, and forests. The remnants of Appalachian culture brought into the area by European settlers is preserved in places like Cades Cove. More than 800 miles of trails, including part of the well-known Appalachian Trail, meander through cove and valley and over ridge tops to the joy of foot travelers. Favorite tourist sites in the park include Clingman's Dome, the Chimney Tops, Mt. Le Conte, and the Newfound Gap Loop. Bears, wild hogs, deer, and elk roam the woods and fields of the Smoky Mountains.

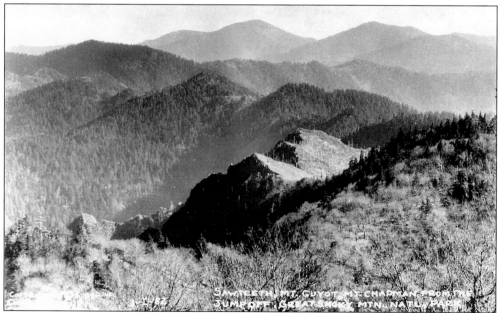

SMOKY MOUNTAIN GRANDEUR. From this view, called the Jumpoff, the jagged Sawteeth (approximately 5,450 feet), Mt. Guyot (6,621 feet), and Mt. Chapman (6,425 feet) can be seen. These mountains lie roughly along the North Carolina–Tennessee state line. (Cline Photo.)

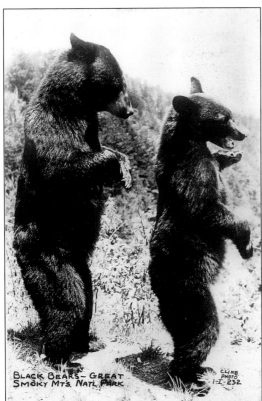

BLACK BEARS. An infrequent roadside attraction and campground menace, black bears roam throughout the Great Smoky Mountains and the Land of the Sky. Warned not to feed them, some disobedient travelers goading the docile-looking animals with food from inside their automobiles have discovered the hard way that hungry bears are not easily deterred by plate glass and sheet metal. (Cline Photo.)

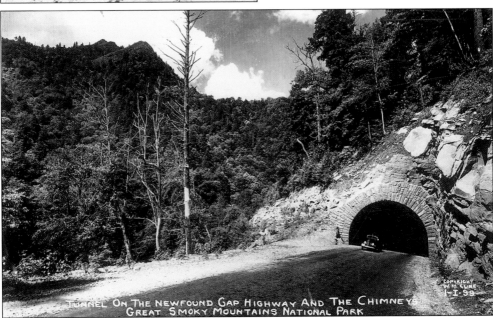

NEWFOUND GAP TUNNEL. A 1940s vintage automobile emerges from a tunnel on the Newfound Gap Highway in the Great Smoky Mountains National Park. The Chimney Tops can be seen on the horizon. Newfound Gap lies on the dividing line between the North Carolina and Tennessee sections of the Smoky Mountains. (Cline Photo.)

THE CHIMNEY TOPS. Located in the Great Smoky Mountains National Park, the twin peaks called the Chimney Tops rise above the summit of Sugarland Mountain. A steep two-mile hike rewards determined hikers with outstanding views from the top. (Cline Photo.)

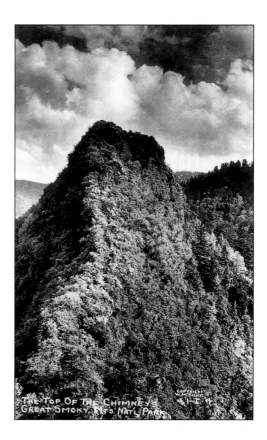

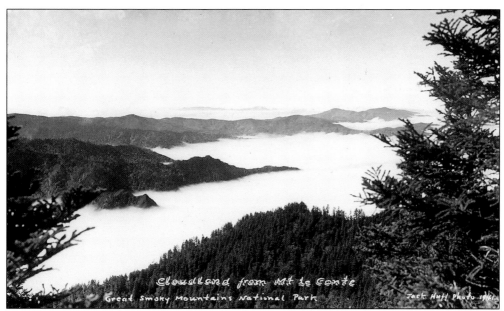

LE CONTE VIEW. This Jack Huff photo, taken about 1941, shows a view from Mt. Le Conte, Tennessee (6,593 feet). Titled Cloudland from Mt. Le Conte, the fog-filled valley below illustrates how the Great Smoky Mountains got their name. (Jack Huff Photo.)

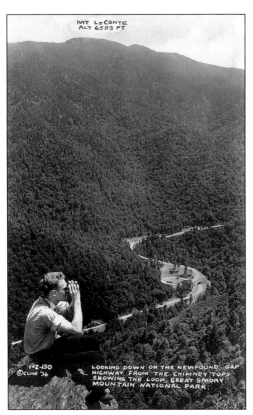

NEWFOUND GAP. A successful climber peers down on the Newfound Gap Highway from the Chimney Tops. Mt. Le Conte is seen on the horizon. The highway Loop is seen below. (Cline Photo.)

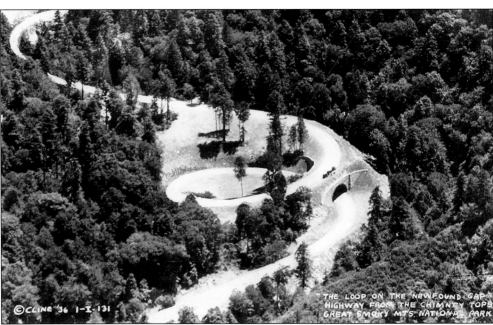

THE LOOP. A well-known landmark to Smoky Mountains travelers, the Loop adds an exciting twist to the serpentine roadway traversing the Great Smoky Mountains National Park. This photograph of the Loop was taken in 1936. (Cline Photo.)

12

CLINGMAN'S DOME TOWER. Topped by a 45-foot timber-framed observation tower, Clingman's Dome (6,642 feet) is the highest point in the Great Smoky Mountains National Park. Clingman's Dome is located along the Swain County, North Carolina–Sevier County, Tennessee line. (Cline Photo.)

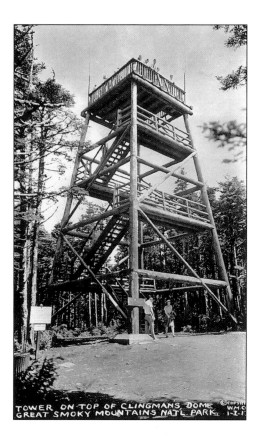

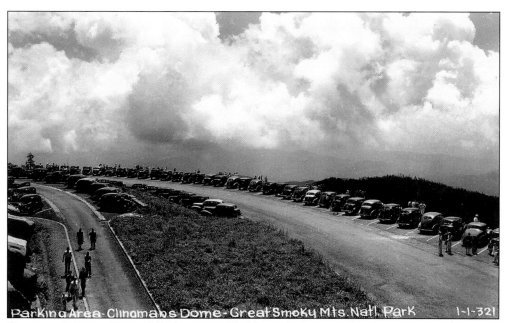

CLINGMAN'S DOME VIEW. All places are filled by parked cars and pedestrians vie for the best views in this photograph of the Clingman's Dome parking lot. (Cline Photo.)

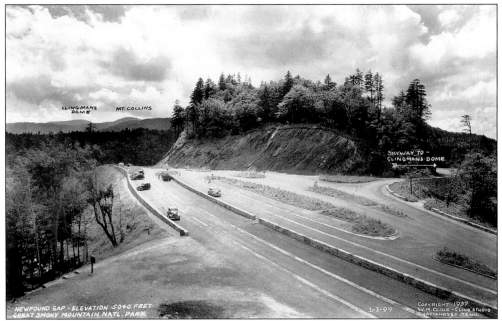

SKYWAY TO CLINGMAN'S DOME. In this 1937 view of Newfound Gap (5,040 feet), the entrance to the Skyway to Clingman's Dome is seen. At more than a mile high over its entire length, this roadway displays its designers' mastery of engineering. The location of Clingman's Dome and Mt. Collins (6,255 feet) can be seen on the distant horizon. (Cline Photo.)

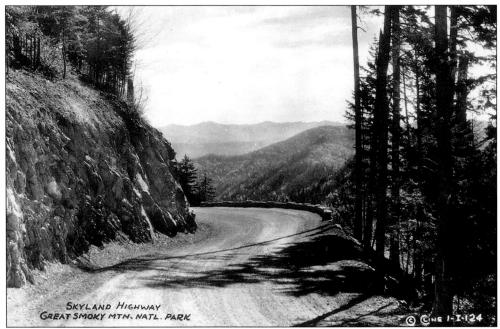

SKYLAND HIGHWAY. Mostly undeveloped and perpetually reserved for its wilderness beauty, the Great Smoky Mountains National Park is infrequently cut by roads like the Skyland Highway, shown here unpaved. (Cline Photo.)

Two

MOUNTAIN PEOPLE

Mostly of Scots-Irish descent, the settlers who came to the mountains of North Carolina were a hardy lot determined to carve out homes and farms from the rugged wilderness they discovered in the highlands above the Blue Ridge escarpment. The hardship of eking out a living from meager crops grown on steep and rocky land, coupled with the wear and tear of harsh winter weather, was tempered among these people to some degree by the joys of family, by music played on homemade instruments, and by singing ballads once sung by their European ancestors. Contrary to the stereotypical image of the mountaineer as a shiftless hillbilly, the people who settled western North Carolina were of necessity an industrious and innovative lot. Having very little to work with, they grew the food they ate, built their own houses, barns, and churches, and wove and fabricated their own clothes. The things they made with their hands frequently surpassed their mere functional requirements, becoming true works of folk art. Not at all unfriendly to outsiders, as some would like to believe, it's with mountain people like an old man once said, "I'm a good neighbor to every feller that comes around here, until he gives me good reason not to be." So the mountaineers welcomed tourists when they began to explore their land. In fact, they took good advantage of their arrival by creating for themselves opportunities to make a little money off of them during their stay.

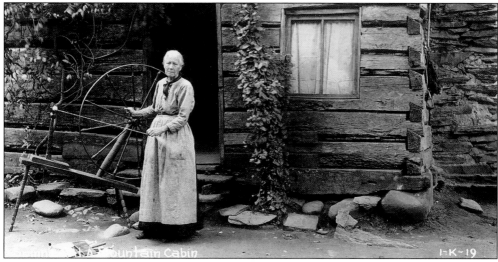

SPINNER. Standing by her large-wheeled spinning wheel—once a common sight in western North Carolina—this woman demonstrates outside her cabin how homegrown wool is turned into thread, which is subsequently woven into cloth. In addition to wool, cotton and flax are spun and woven to make the fabrics required for coverlets, quilt tops, table cloths, and everyday clothing. (Cline Photo.)

15

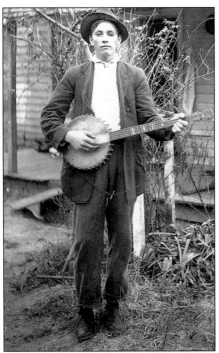

WATAUGA COUNTY BANJO PLAYER. Mountain people and their mountain customs become the unsolicited focus of many travelers who come to western North Carolina. Considered quaint and backward by some outsiders, mountain people prove by their adaptability, creativity, and resilience, when faced with the hardships of high country life, that they are champions of the land so many people desire to visit and explore. This young man, said to be a resident of the Sugar Grove community in Watauga County, near Boone, North Carolina, stands posed with a five-string banjo, one of many instruments played throughout the Appalachian region by traditional musicians.

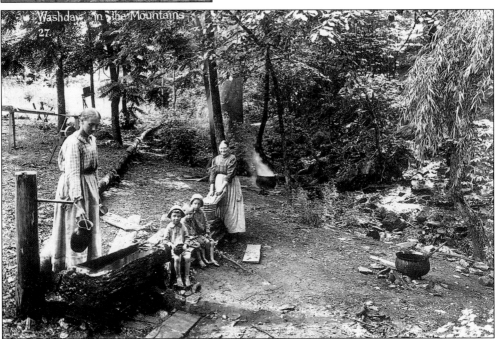

WASHDAY IN THE MOUNTAINS. Only a short time ago, a roadway traveler might encounter a picturesque view of mountain women and children like these at work doing the hard labor of washing a week's worth of clothes outdoors in great iron kettles, heated by the embers of burning wood and rinsed with water drawn from a cold mountain stream. Here, one woman fills a locally made stoneware pitcher with water while another scrubs her laundry on a washboard. Two young children look on as the day's work proceeds. (Asheville Post Card Company.)

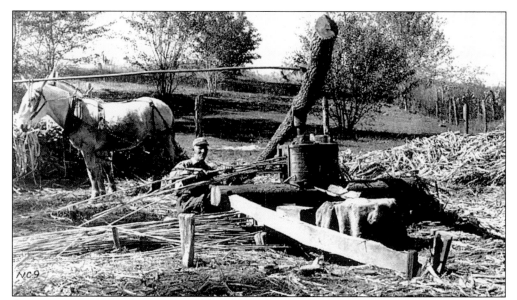

GRINDING CANE. Sorghum, a cane-like plant whose stalks contain sweet juice, is grown and used to make molasses and sweetener for home consumption. Here, a Blue Ridge mountain homesteader, with the aid of his horse team and a cane mill, grinds and squeezes sorghum to extract its sugar-laden juice. (N.C. Department of Conservation and Development.)

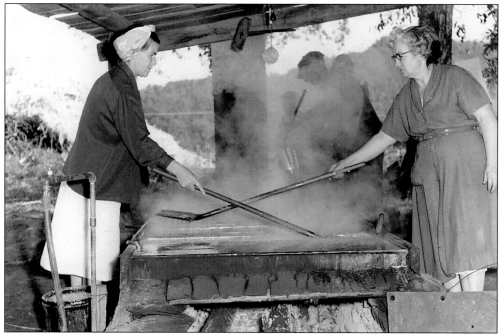

BOILING MOLASSES. Once collected, sorghum juice is boiled and evaporated in shallow pans heated by burning wood. These women are constantly skimming the ever-thickening juice and will do so until a sweet, sticky syrup develops in the pan. Once cooled, molasses is stored and used throughout the year. Lucky travelers can sometimes view molasses making at community harvest festivals. Savvy mountaineers sell molasses, honey, apple butter, jams, jellies, and other homemade products at roadside stands.

ITINERANT DOCTOR. The card reads, " 'The boy doctor' Swannanoa, N.C. 1907." Lacking in hospitals and medical personnel, mountain people and travelers alike once depended upon the likes of this young traveling physician. Swannanoa (2,220 feet) is a community in southeastern Buncombe County and is named for the river on which it is located.

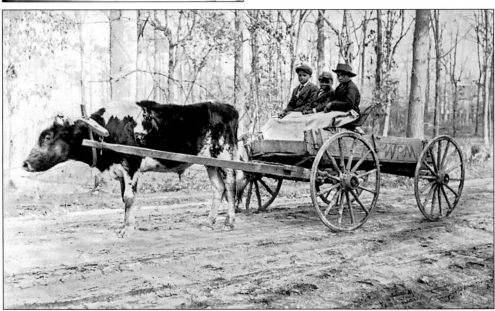

RAPID TRANSIT. This ox-drawn wagon with its three young occupants demonstrates a common mode of transportation utilized by mountain people for many decades. Before hard-surfaced roads were introduced to the region, an ox-powered vehicle like this one might prove a more reliable mode of transportation than the finest motor vehicle available. This fact alone restricted access to the mountain region, with its rough terrain and paltry roads, to all but the most adventurous travelers before the early years of the 20th century. This picture was made near Hendersonville, North Carolina (2,146 feet).

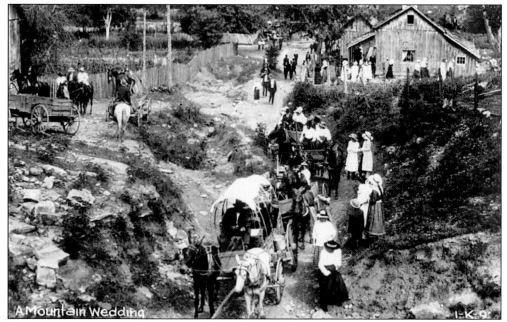

MOUNTAIN WEDDING. The occasion of a wedding, such as the one depicted in this photograph, would be quite a sight for any tourist who happened by. Five wagons, numerous horses, and men and women dressed in their best attire flood the lane and pathways of this community. (Cline Photo.)

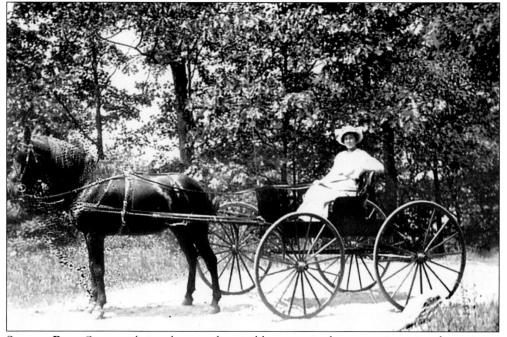

SUMMER RIDE. Summer, being the more hospitable season in the mountain region than winter, affords this handsomely dressed woman the chance to take a buggy ride on Asheville's Sunset Mountain. Sunset Mountain is the site of the well-known Grove Park Inn, admired for its massively rustic architecture and arts and crafts decor.

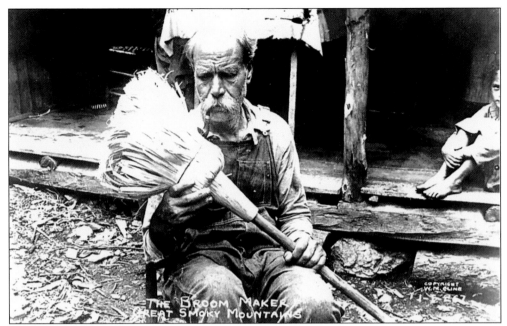

BROOM MAKER. This man demonstrates his skill at making an essential household item; the broom is made of a cane-like grass called broomcorn. Once made only for personal use, such items were sometimes purchased by tourists as souvenirs of the mountaineers' "rough ways" or to use themselves at home. Whether a dime or a dollar was paid for such items, the much-needed income has been a blessing to many mountain artisans. (Cline Photo.)

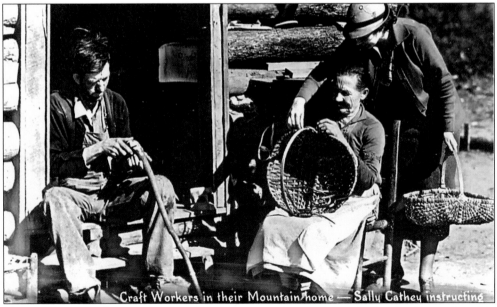

CRAFT WORKERS. A man whittles while his companion weaves a basket in this rustic cabin doorway scene. The instructor (right) is Sally Cathey, one of a number of people who helped mountain artisans create a handicraft industry from their skill to make beautiful handmade items from wood, fabric, metal, and clay. (Photo card made for Blue Ridge Weavers, Mountain Crafts, Tryon, North Carolina.)

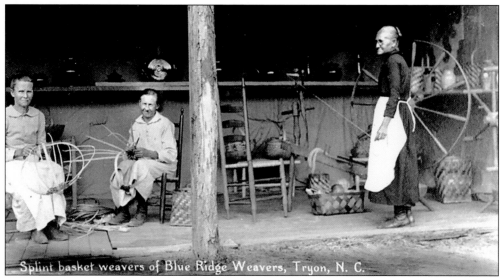

Splint basket weavers of Blue Ridge Weavers, Tryon, N. C.

ARTISANS AT WORK. In this one scene various handicraft products, once primarily made for home use but increasingly to sell to souvenir-hungry tourists, can be seen. In addition to the baskets being crafted by the two women seated and those on shelf and floor around them, an array of handmade chairs, a hooked rug, and a spinning wheel and yarn winder are on display. Although pottery was made in the mountain region, the selection displayed on the shelf located behind the workers was made by Jugtown Pottery in the Piedmont section of the state in rural Moore County. (Photo card made for Blue Ridge Weavers, Mountain Arts and Crafts, Tryon, North Carolina. Courtesy of Arthur Baer.)

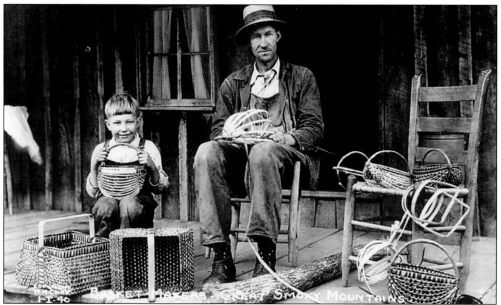

WHITE OAK BASKETRY. Mountain settlers of European origin brought with them their craft traditions. In this scene, a basket maker and his smiling young assistant show how white oak, a native tree of the region, is split from a log (lying on the floor to the right of the man's feet), shaved into thin, flexible splints, and then woven into baskets of various sizes and shapes. (Cline Photo.)

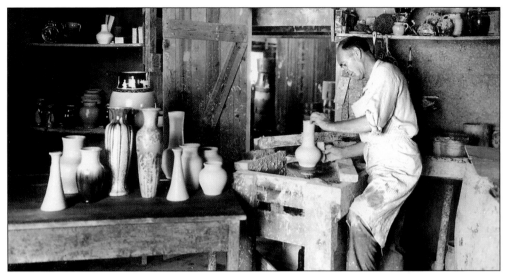

POTTER AT WORK. Pottery, both earthenware and stoneware, was produced in the mountain region, particularly around Buncombe County near Asheville. An early traveler might have encountered a potter and his assistants burning a large kiln load of utilitarian jugs and crocks. Early 20th-century potters increasingly turned from making utilitarian wares to more decorative pottery for home decoration. This photograph shows Walter Stephen, founder of Pisgah Forest Pottery, located near Arden, North Carolina, surrounded by a beautiful collection of his work. Tourists often purchased earthenwares directly from the region's potters and at roadside stands. Once viewed as trinkets having little value beyond their reminder of one's vacation travels, the surviving work of some mountain potters is highly valued by collectors and museums. Other notable early 20th-century potteries in the region include Hilton Pottery, Omar Khayyam Pottery, and Brown Pottery. (Photo by Elliot Lyman Fisher.)

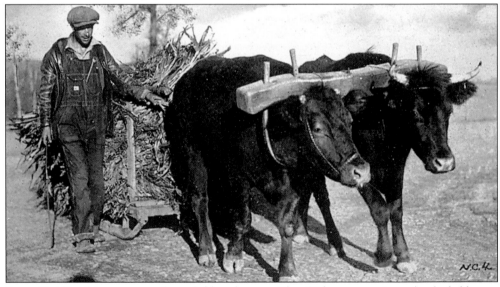

SLED. Guiding his two oxen from field to barn, a Blue Ridge mountaineer hauls fodder on a primitive sled. Old ways sometimes continued in the mountain region long after their abandonment in more developed communities, providing travelers the opportunity to reminisce about days gone by. (N.C. Department of Conservation and Development.)

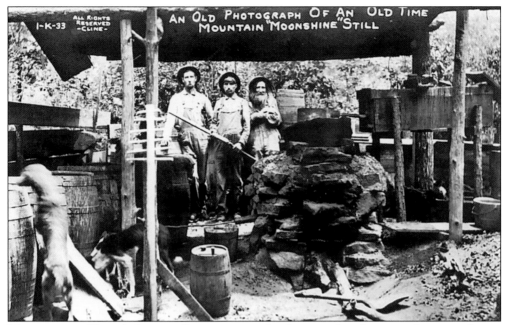

AN OLD PHOTOGRAPH OF AN OLD TIME MOUNTAIN "MOONSHINE" STILL

MOONSHINERS. Though they usually went unseen by the typical roadway traveler, moonshiners and their whiskey-producing stills were nevertheless present in every mountain community. Some cautious inquiry might lead a weary and bone-chilled traveler to the location of a stone jug or a glass jar filled with the high-test nectar produced by these high-country entrepreneurs. These three businessmen and their two hound dogs (lower left corner) seem ready to fight off an intruding revenuer or to fill a jug or two at a customer's request. (Cline Photo.)

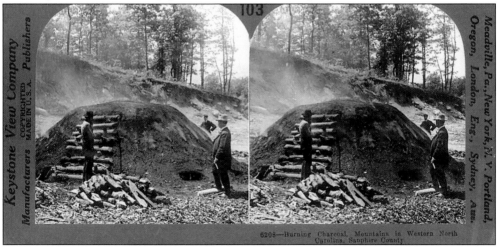

6208—Burning Charcoal, Mountains in Western North Carolina, Sapphire County

MAKING CHARCOAL. Need charcoal for your vacation campfire or grill? These three gentlemen can provide what you need. The practice of charcoal making was once prevalent in the mountains of western North Carolina, a region having too little good farm land but an abundance of wood products. Charcoal is made by stacking tiers of wood into a mound and covering it with soil, leaves, grass, and straw. The fire burns down into the mound from top to bottom until the fire burns itself out. When uncovered, the mound reveals a pile of black, porous charcoal. Charcoal is used for fuel, gunpowder, in chemicals, and in crayons. (The Keystone View Company.)

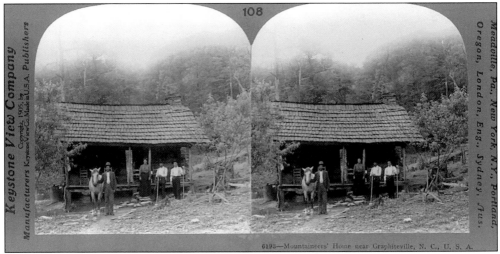

108

6193—Mountaineers' Home near Graphiteville, N. C., U. S. A.

CABIN HOME. The modest home of a mountaineer family boasts little for comfort. Here, four individuals stand posed in front of their cabin with its porch, shake-shingled roof, and single stone chimney. Ready for field work, the man on the left holds his horse in place; a plow rests on the ground to the far right of the image; two young men stand hoes in hand. Largely of Scots-Irish descent, many mountain families continued the traditions of their ancestral land, including singing ballads of distinctly European origin. (The Keystone View Company.)

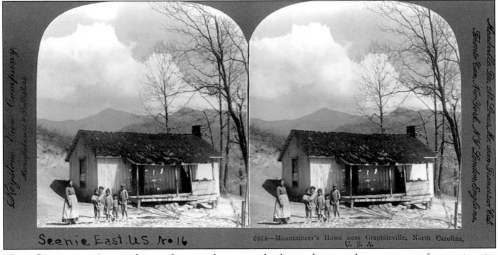

Scenic East U.S. No. 16

0924—Mountaineer's Home near Graphiteville, North Carolina, U. S. A.

HILL CHILDREN. A two-door cabin, with sawn planks and a weather-worn roof covering its exterior, probably offered little more than comfort to its occupants on the inside. This family, whose meager home is shown, includes at least five children. Without compulsory school laws and with little means to travel to hard-to-reach schools, there was little incentive for children of these hardscrabble families to obtain a formal education. The advent of tourists into the region was sometimes the first indication to children and some adults of what the flat-landers' world was like. Some compassionate visitors to the mountain counties of the state were determined to find ways to provide for the education of the region's children. (The Keystone View Company.)

Three

HIGH COUNTRY
TOWNS AND PLACES

Scattered throughout the high country of western North Carolina are a few small cities of note, such as Asheville and Boone, Waynesville and Hendersonville, and many more small villages, towns, and hamlets. Each place seems to take on its own character shaped by the people who settled there or by those who come to visit. Linville, for example, has the air of a place reserved for an affluent lot of people who value the privacy and comfort of their own personal getaway retreats. Asheville distinguishes itself as an avant garde outpost for people of all walks of life, who do not mind expressing themselves in freely outlandish ways, side-by-side with folks who are as conservative as the local parson's wife. There are places hard to find on any map, like Rominger and Sugar Grove, where time seems to stand still. These are the places where mountain folks come to resupply and travelers come to eat, sleep, shop and play.

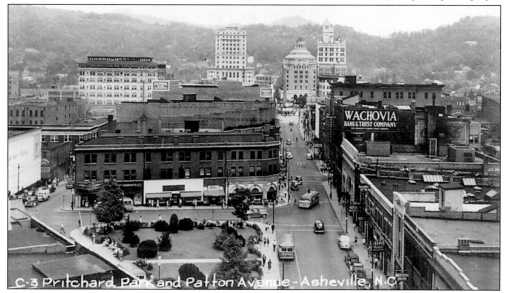

ASHEVILLE. Located on the French Broad River in central Buncombe County, the city of Asheville (2,216 feet) is noted for its Art Deco architecture, mild climate, and reputation as a health and tourist resort. The city is home to author Thomas Wolfe (*Look Homeward Angel*). This view shows Pritchard Park and Patton Avenue, as well as Pack Square in the background. (Cline Photo.)

BOONE TRAIL. A large arrowhead-shaped monument stands near Beaucatcher tunnel in Asheville. Here called the Appalachian Indian Road, roads bearing similar markers are located throughout western North Carolina at places purportedly traveled by Daniel Boone, a native of the state who explored and hunted the high country.

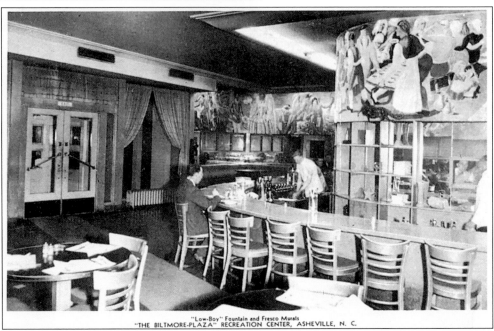

"Low-Boy" Fountain and Fresco Murals
"THE BILTMORE-PLAZA" RECREATION CENTER, ASHEVILLE, N. C.

BILTMORE PLAZA. The Biltmore Plaza Recreation Center supplied dining, a soda fountain, dancing, and bowling—both Ten Pens and Duck Pins—to Asheville visitors and residents alike. Located in historic Biltmore Village, the site has a 200-foot-long fresco mural gracing the curving wall above the soda fountain.

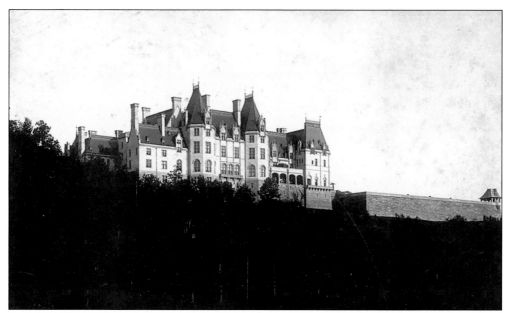

BILTMORE HOUSE. Found in central Buncombe County, near Asheville, the famed 780-foot-long Biltmore was constructed for George Vanderbilt between 1890 and 1895. Following his death, the French chateau-styled house, with its ample furnishings inside and gardens, forests, and a dairy farm surrounding it, was opened to the public, making it a leading tourist destination. This photograph was made in 1903, only eight years after construction of the house. (Photo by C.F. Ray, Asheville, North Carolina.)

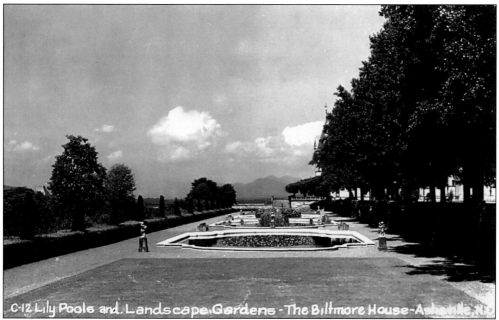

BILTMORE GARDENS. Although it covered four acres, the Biltmore house was surrounded by 12,000 acres of mountain forest land. George Vanderbilt employed noted landscape architect Frederic Law Olmsted Sr. to design a landscape plan for the property. This view of lily pools and gardens provides a small glimpse of all that Olmsted devised in his design. (Cline Photo.)

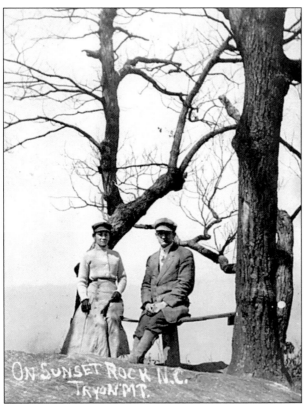

TRYON. Named for nearby Tryon Mountain, the town of Tryon (1,075 feet) is located in Polk County, North Carolina. Early in the 20th century, the town became a haven for artists and is noted for both fine art and handicrafts produced by its residents. Here, a couple enjoys a cool weather outing at Tryon Mountain's Sunset Rock.

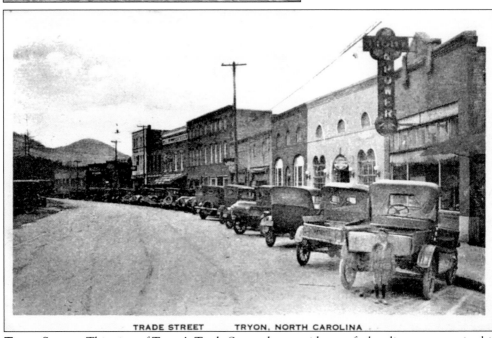

TRADE STREET TRYON, NORTH CAROLINA

TRADE STREET. This view of Tryon's Trade Street shows evidence of a bustling economy in this small Polk County mountain town. A young boy, dressed in short pants, knee high socks, and a cap, poses for the photographer.

28

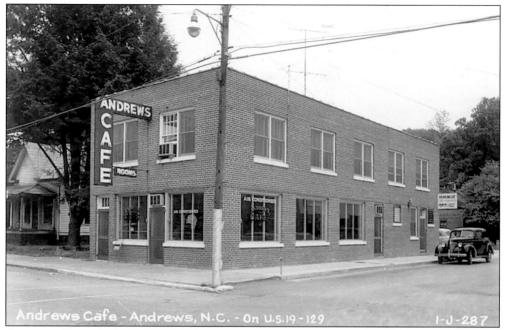

ANDREWS. Typical of many convenient town cafes, Andrews Cafe afforded visitors good food at reasonable prices. Andrews Cafe, located on U.S. 19-129, was located in the town of Andrews (1,825 feet) in Cherokee County. (Cline Photo.)

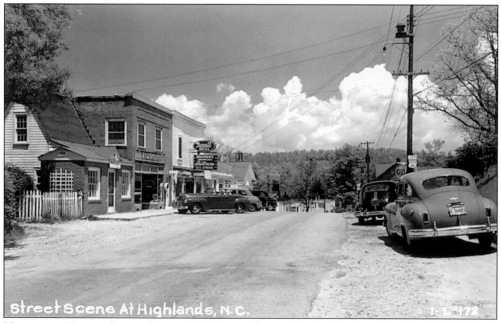

HIGHLANDS STREET SCENE. Situated in Macon County, North Carolina, Highlands (3,838 feet) is the highest town in the state. Highlands was established as a summer resort in 1875. This street scene boasts an antique shop, a Rexall Drug Store offering sandwiches, souvenirs, and Biltmore ice cream, and two Gulf gasoline stations. (Cline Photo.)

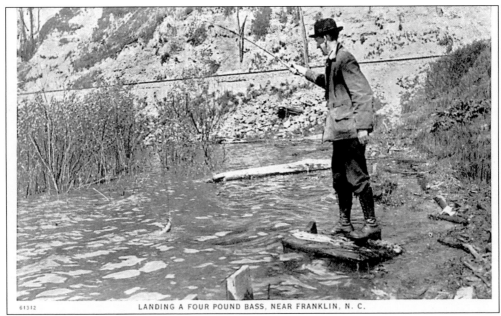

LANDING A FOUR POUND BASS, NEAR FRANKLIN, N. C.

FISHING NEAR FRANKLIN. The town of Franklin (2,113 feet) was settled early in the 19th century. Nikwasi, an old Cherokee town, was here and is marked by an extant earthen mound. Located on the Little Tennessee River, Franklin affords this man a fine opportunity for fishing in the cold waters of the Appalachians. (Asheville Post Card Company.)

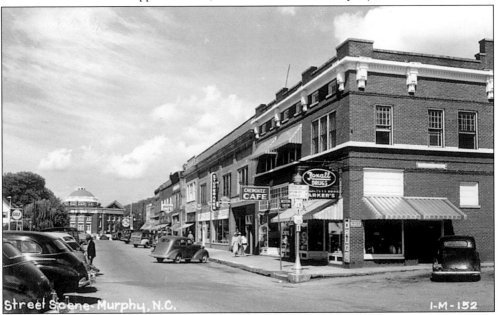

Street Scene- Murphy, N.C. I-M-152

MURPHY STREET SCENE. Located at the junction of the Hiwassee and Valley Rivers, the town of Murphy (1,535 feet) is located in Cherokee County near the westernmost point in North Carolina. This street scene shows the court house, the Evans Studebaker dealership, the Cherokee Cafe, a Gulf gasoline station, a Western Union office, and a Rexall Drug Store. The road sign located on the corner in front of the drug store indicates that Murphy is 68 miles from Fontana Dam, 49 miles from Bryson City, and 112 miles from Asheville. (Cline Photo.)

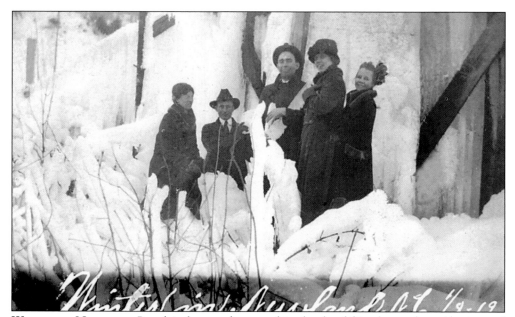

WINTER IN NEWLAND. Posed in hats and coats, this clutch of friends stands amidst ice and snow in the town of Newland (3,589 feet) in Avery County. The hardships of winter in the mountains of western North Carolina for many years severely limited travel access to the high country, though a few hardy souls like these dared to venture into the area.

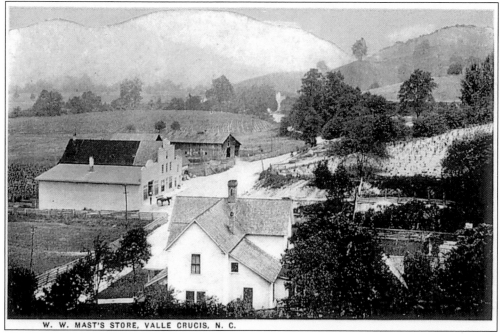

W. W. MAST'S STORE, VALLE CRUCIS, N. C.

MAST'S STORE. This early view of Valle Crucis (3,000 feet) shows the Mast family homestead and W.W. Mast's general store. The valley, for which Valle Crucis is named, is home to an Episcopal mission established in 1842. Located in Watauga County, near Boone, North Carolina, Valle Crucis is situated along the Watauga River. Mast's Store is a popular tourist destination today.

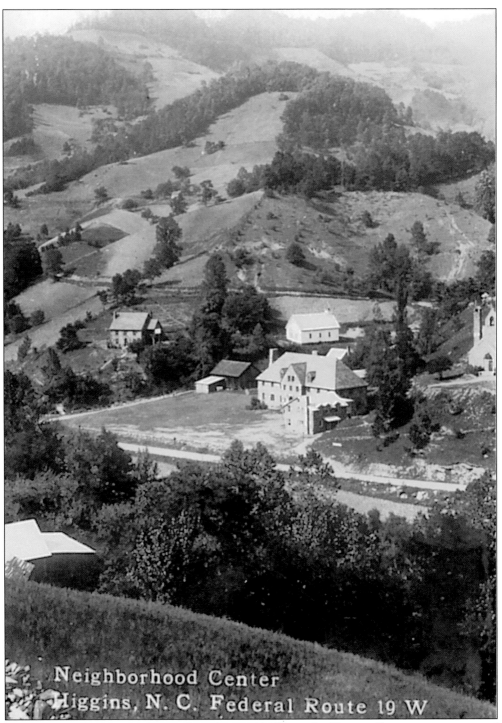

Neighborhood Center
Higgins, N. C. Federal Route 19 W

HIGGINS NEIGHBORHOOD. Located on Route 19 West, the Yancey County community of Higgins (2,390 feet) sits on the Cane River. This view is typical of those seen by travelers who chose to explore the more remote backcountry of the Appalachians on the region's first developed highways.

Four

NATURAL WONDERS

Before any tourist attraction was ever devised by a clever entrepreneur, the mountains of western North Carolina beckoned tourists with their fabulous natural wonders and breathtaking scenic views. Places like Chimney Rock, Grandfather Mountain, Mount Mitchell, Roan Mountain, the Blowing Rock, Mount Pisgah, Linville Falls, Nantahala Gorge, Whiteside Mountain, and Caesar's Head were well known to able travelers long before Tweetsie Railroad made its first round on its narrow-gauge railway loop. Some of these scenic venues were first known by the Cherokee Indians, who first lived in the land, then by early explorers and adventurers such as Spain's Hernando De Soto in the 16th century, botanist William Bartram, explorer and naturalist Andre Micheaux, and scientist Elijah Mitchell. Today, against the competition of theme parks and casinos, these natural places continue to hold their own as favorite destinations for travelers.

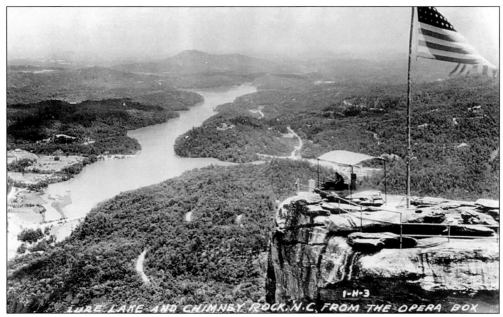

LAKE LURE. Formed in 1928 to accommodate a resort's residents, Lake Lure's 1,500 acres of surface area are formed by a 104-foot dam on the Broad River in Rutherford County. This view is taken from the Opera Box, a trail overlook site near the Chimney Rock. (Cline Photo.)

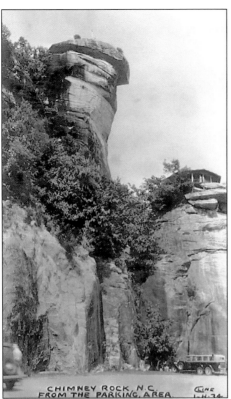

CHIMNEY ROCK PARKING AREA. Tourists seeking a cool climate and scenic views were often drawn first to Chimney Rock, located on the approach to the higher mountain country surrounding Asheville, North Carolina. Here, at the base of the Chimney Rock, is seen an automobile and a triple-axled vehicle used to transport visitors up the road to the final approach to the summit. (Cline Photo.)

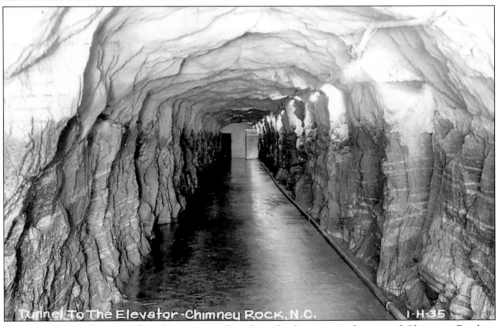

CHIMNEY ROCK TUNNEL. For those not inclined to climb stairs to the top of Chimney Rock, a 198-foot-long tunnel and a vertical 258-foot-high elevator shaft were blasted into the mountain to afford an easier, less strenuous route to the top. Opened in 1949, the elevator whisks visitors to the top in 30 seconds. (Cline Photo.)

CHIMNEY ROCK PARK. A steep, 470-step staircase leads the most energetic visitors to the flag-topped pinnacle called Chimney Rock, located in Rutherford County, North Carolina. Surrounding the mountain, which hosts the Chimney Rock monolith, is a resort community by the same name (1,050 feet). (Cline Photo.)

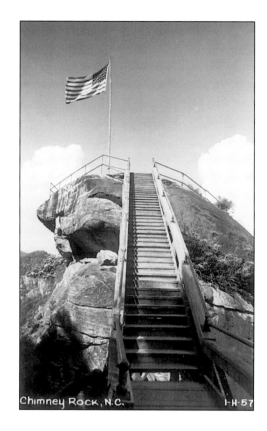

Chimney Rock, N.C. I-H-57

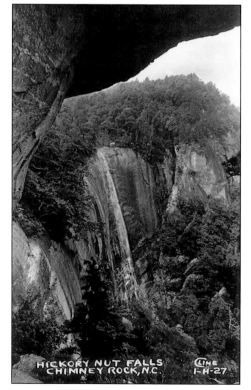

HICKORY NUT FALLS
CHIMNEY ROCK, N.C. Cline
 I-H-27

HICKORY NUT FALLS. Located on the Broad River, Hickory Nut Falls (404 feet high), is located in Rutherford County near Chimney Rock. Good views of the falls and Hickory Nut Gorge are possible from trail outlooks, Peregrine's Rest, and Inspiration Point. The climactic fight scene in the film *The Last of the Mohicans* was filmed at the top of Hickory Nut Falls. (Cline Photo.)

35

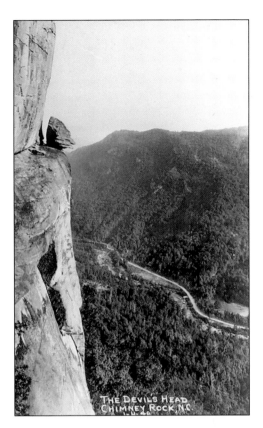

THE DEVIL'S HEAD. Peering out over Hickory Nut Gorge is the easily recognizable Chimney Rock Park feature known as the Devil's Head. The Skyline Trail leads by this viewpoint on its way to the top of Hickory Nut Falls. (Cline Photo.)

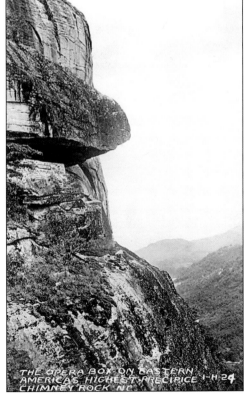

THE OPERA BOX. A spectacular view of Lake Lure is enjoyed by visitors to the Opera Box in Chimney Rock Park. Formed by the separation of two layers of Henderson Augen gneiss, the stone that makes up Chimney Rock's numerous geologic features, the Opera Box has long been a favorite stopping point for visitors on their way to view Hickory Nut Falls. (Cline Photo.)

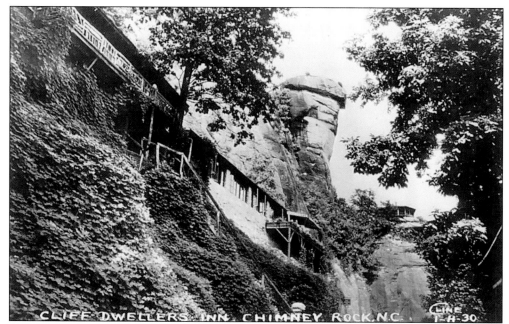

CLIFF DWELLER'S INN. Built around 1920, Chimney Rock's Cliff Dweller's Inn once offered ten two- and three-bedroom cottages set on a ledge and nestled against the side of the mountain. The Cliff Dweller's Inn was removed in 1948 to make way for the construction of a 198-foot tunnel and 258-foot elevator shaft leading to the top of the Chimney Rock precipice. (Cline Photo.)

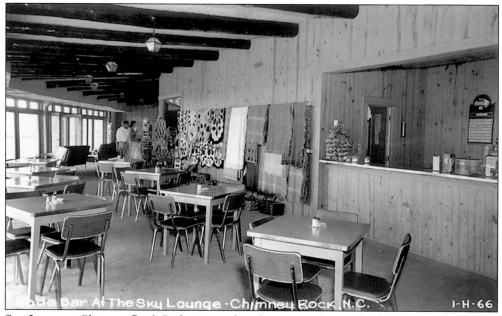

SKY LOUNGE. Chimney Rock Park visitors found respite and nourishment at the Sky Lounge, where, in addition to the offerings of a soda fountain, they could purchase locally made handicrafts and souvenirs. Hooked rugs, woven coverlets, and splint baskets are arrayed against knotty-pine walls in this photo. (Cline Photo.)

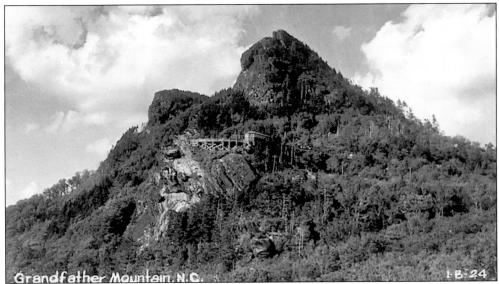

GRANDFATHER MOUNTAIN. At 5,964 feet, Grandfather Mountain is considered the highest in the Blue Ridge range of the Appalachian Mountains. A privately owned property, Grandfather Mountain has long been a favorite tourist destination. Perhaps best known in its early years of public access for its magnificent rock formations, plant life, fall tree color, and long-range views, in more recent times the location has been known for its mile-high swinging bridge, wild animal habitat area, nature museum, and as the site for the annual Scottish Highland Games. Grandfather Mountain is located near the Blue Ridge Parkway on U.S. Highway 221, two miles north of Linville, North Carolina. This view shows an old wooden trestle and lookout point positioned along the roadway to the top of the mountain. (Cline Photo.)

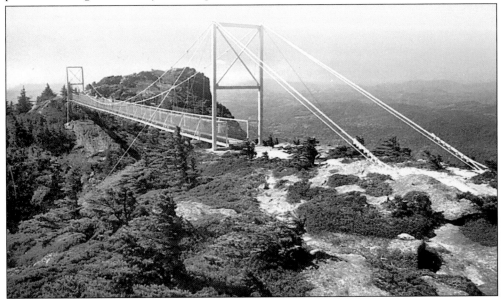

MILE-HIGH SWINGING BRIDGE. Considered a mile-high bridge due to its 5,305-foot elevation above sea level, this frightening yet favorite feature of a Grandfather Mountain visit has drawn tourists to the site for years. The bridge's 228-foot span, for pedestrians only, connects Convention Table Rock to the spectacular Linville Peak. (Hugh Morton Photo.)

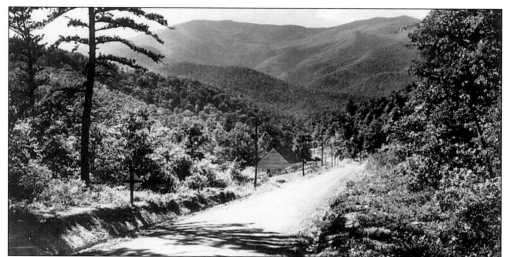

MOUNT MITCHELL. The highest peak in eastern North America, Mount Mitchell rises to 6,684 feet above sea level. Formed more than a billion years ago, the Black Mountains, of which Mount Mitchell is a part, began their stand against the ravages of erosion that would lower most of the Appalachian Mountains to their present-day modest heights. Including Mount Mitchell, six peaks in the 15-mile long Black Mountain range are among the ten highest in the eastern United States. In 1915, Mount Mitchell was designated North Carolina's first state park. The view in this photograph was taken from Buck Creek Gap, North Carolina. (Cline Photo.)

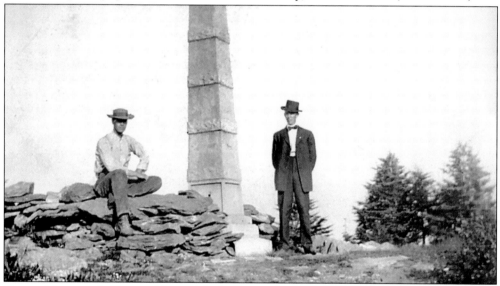

ELISHA MITCHELL'S GRAVE. Mount Mitchell gained its name from one of its early explorers, Dr. Elisha Mitchell. Mitchell, a science professor at the University of North Carolina, made measurements of the mountains in the Black Mountain range, proving the mountain that would one day bear his name was higher than Grandfather Mountain (once considered the highest in the Appalachians). His calculations, made around 1835, proved to be accurate to within 12 feet when compared to modern measurements. Unfortunately, Dr. Mitchell fell from a cliff while hiking above a 40-foot waterfall in the Black Mountains and drowned in the water below. First buried in Asheville in 1857, his body was reburied at the top of Mount Mitchell in 1858. The monument shown in this photograph was erected near his grave around 1888.

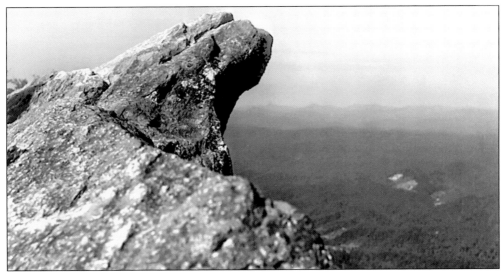

BLOWING ROCK. Hovering 3,000 feet high above the Johns River Gorge is the Blowing Rock, a rock feature that is part of an immense cliff face resting some 4,000 feet above sea level. From the Rock, visitors can view Grandfather Mountain, Mount Mitchell, Table Rock, and Hawksbill Mountain. Legend has it that a Cherokee brave, his heart torn between his love of a beautiful Indian maiden and his duty to his faraway tribe, jumped from the rock into the gorge below. Praying daily to the Great Spirit, the maiden dreamed of the return of her lover until one day a gust of wind blew up from the valley below, landing her Indian brave on the Blowing Rock and into her arms. The Blowing Rock, open to the public since 1933, claims to be North Carolina's oldest travel attraction. It is located on Highway 321 near the resort town of Blowing Rock. (Cline Photo.)

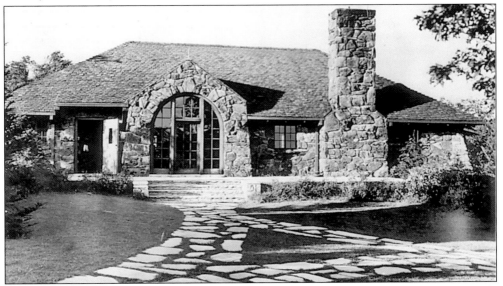

THE ROCK TAVERN. Located in the resort town of Blowing Rock, North Carolina (3,586 feet), this attractively designed and constructed watering hole is part of a village dedicated to the more affluent traveler. Originally a summer retreat from flatland heat and humidity, the town of Blowing Rock has increasingly become a year-round getaway for a broad class of people. Equestrians, golfers, and shoppers alike find a home in Blowing Rock. (Cline Photo.)

LINVILLE FALLS. Long a tourists' favorite among the many waterfalls found in western North Carolina, Burke County's Linville Falls (150 feet high) has a large volume of water pouring over it year round. The upper falls, until about 1900, were nearly equal in height to the lower falls. Flooding caused a collapse in the rock structure of the falls, making the lower portion the dominant feature today. Named for brothers William and John Linville, who were killed by Indians near the falls in the 18th century, the falls are fed by the Linville River, which flows through the Linville Gorge, said to be the wildest gorge in the eastern United States. The Linvilles are said to be relatives of Daniel Boone's wife. The village of Linville Falls (3,325 feet) is located nearby. (Cline Photo.)

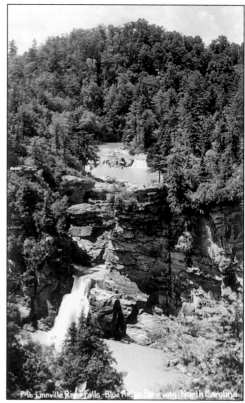

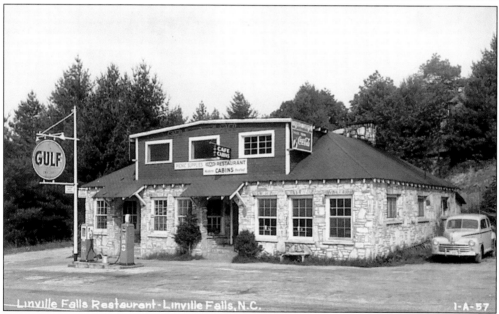

LINVILLE FALLS RESTAURANT. Like trading posts of years gone by, this roadside outpost, offering Grade A food, modern heated cabins, picnic supplies, and gasoline, is a welcome site to road weary travelers. The building, constructed of local stone, is located in the Linville Falls community near the waterfalls bearing the same name. (Cline Photo.)

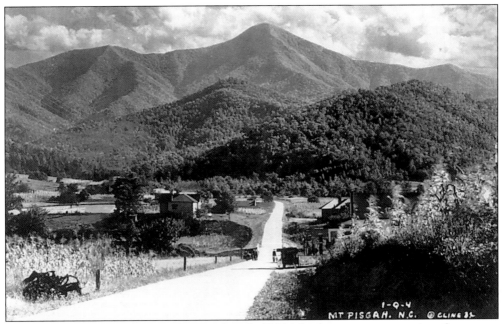

MOUNT PISGAH. From the top of Mount Pisgah (5,721 feet) visitors can peer into five states, including North Carolina, South Carolina, Georgia, Tennessee, and Virginia. The name is derived from the name of the biblical mountain from which Moses looked into the Promised Land. Mount Pisgah is located on the Buncombe-Haywood County line and is reached by way of the Blue Ridge Parkway. (Cline Photo.)

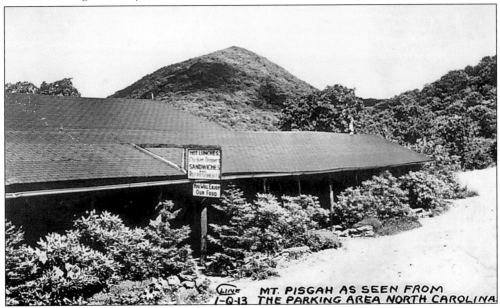

PISGAH INN. Featuring hot lunches, chicken dinners, sandwiches, and refreshments, this wayside cafe near Mount Pisgah and the Pisgah Inn boasts on its sign that "You will like our food." The summit of Mount Pisgah can be seen in the background. The original Pisgah Inn was a rustic structure erected about 1919. A more modern building was constructed after 1960. (Cline Photo.)

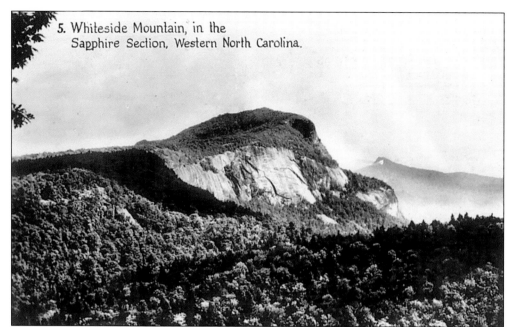

5. Whiteside Mountain, in the Sapphire Section, Western North Carolina.

WHITESIDE MOUNTAIN. Once visited by De Soto in 1540, Whiteside Mountain is found in southwest Jackson County near the town of Highlands. A rock precipice 1,800 feet high is the source of the mountain's name.

CAESAR'S HEAD. A rocky precipice offering long views into the flat lands of South Carolina, Caesar's Head is located near Hendersonville, North Carolina. Nearby is the site of an agreement between North Carolina and Georgia stating that Georgia had no right to a section of land once known as the Orphan Strip. The name Caesar's Head came from the belief that the rocky feature resembled Caesar, the landowner's dog.

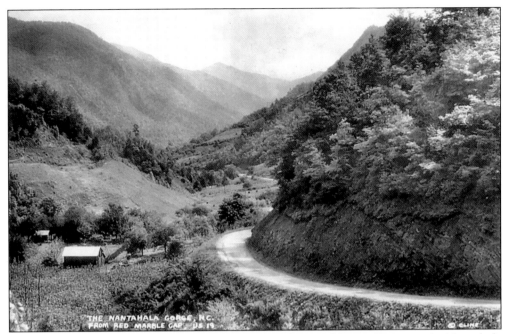

NANTAHALA GORGE. Found at the conjunction of Graham and Swain Counties, the Nantahala Gorge is a narrow, steep-walled canyon through which flows the Nantahala River. The gorge is known by the Cherokee Indians as the Land of the Middle Sun, suggesting that only the noon sun could brighten its dim depths. This view, from Red Marble Gap, rests at about 2,750 feet above sea level. (Cline Photo.)

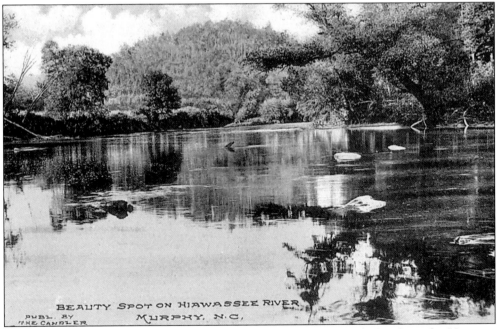

HIWASSEE RIVER. One of many scenic rivers found in western North Carolina, the Hiwassee flows into the state from Georgia, then through Lake Chatuge, Hiwassee Lake, and Apalachia Lake into Tennessee and the Tennessee River.

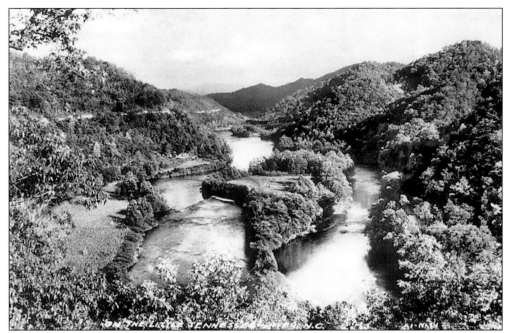

LITTLE TENNESSEE RIVER. Discovered by De Soto's expedition in 1540, the Little Tennessee River flows from Georgia into North Carolina and through Lake Emory, Fontana Lake, and Lake Cheoah before joining the Tennessee River in Tennessee. (Cline Photo.)

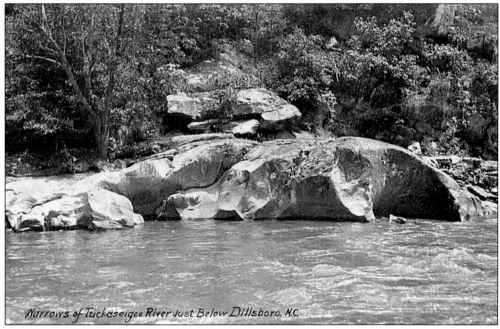

TUCKASEGEE RIVER. Named for the Cherokee word for "crawling terrapin," the Tuckasegee River flows through Jackson and Swain Counties before joining the Little Tennessee River. In this view, the river passes just below Dillsboro, North Carolina, a popular tourist destination known for its food, lodging, and crafts.

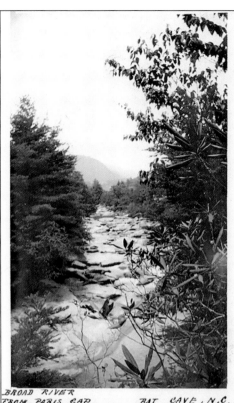

BROAD RIVER. Seen from Paris Gap, near Bat Cave, North Carolina (1,250 feet), the Broad River shown in this image runs through Hickory Nut Gorge and Lake Lure. It joins the Saluda River at Columbia, South Carolina.

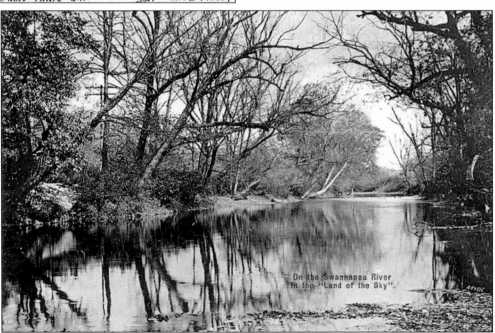

SWANNANOA RIVER. Rising near the Buncombe-McDowell County line, the Swannanoa River flows toward Asheville where it joins with the French Broad River. (Hackney and Moale, Asheville, North Carolina.)

QUEENS CREEK FALLS. Once located on Queens Creek, a tributary of the Nantahala River, these falls were obliterated when water was diverted for a hydroelectric project. (Cline Photo.)

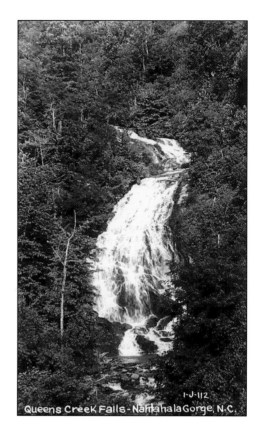

Queens Creek Falls - Nantahala Gorge, N.C.

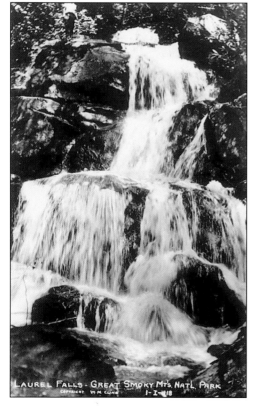

LAUREL FALLS - GREAT SMOKY MT'S NATL PARK

LAUREL FALLS. Hidden in the Great Smoky Mountains National Park, Laurel Falls cascades 75 feet over ledges and boulders, ending in a pool where visitors often cool their feet. (Cline Photo.)

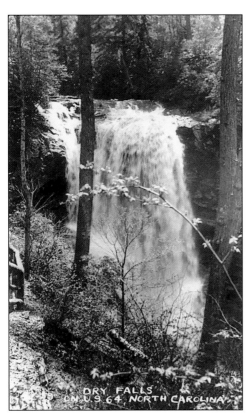

DRY FALLS. Undoubtedly, these falls are not named for a lack of water. Formed by water rushing 75 feet over a protruding ledge, visitors can walk behind the water without getting soaked, hence the name. Dry Falls is located on the Cullasaja River, near Highlands, North Carolina. (Cline Photo.)

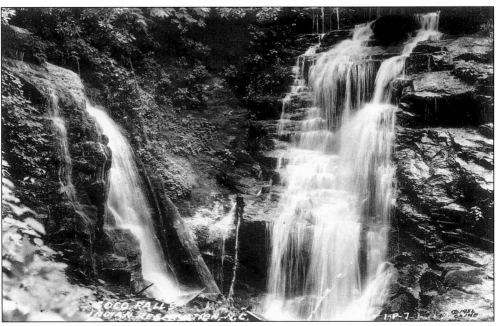

SOCO FALLS. This double-stream waterfall, located within the Cherokee Indian reservation boundary, falls over a series of ledges for about 60 feet. Legend has it that the Cherokee threw one of De Soto's men into these falls. (Cline Photo.)

CULLASAJA FALLS. Falling about 310 feet in one-quarter mile, the Cullasaja Falls are found on the Cullasaja River. Rising in Macon County, North Carolina, and flowing into the Little Tennessee River, the Cullasaja River hosts Bridal Veil, Dry, and Lower Cullasaja Falls. (Cline Photo.)

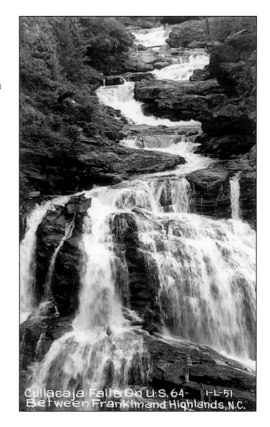

Cullasaja Falls On U.S. 64- I-L-51 Between Franklin and Highlands, N.C.

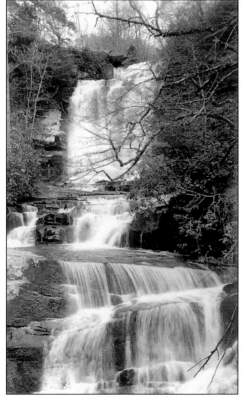

CONNESTEE FALLS. Carson Creek in Transylvania County is the location for Connestee Falls. According to Cherokee legend, the falls are named for Princess Connestee, who leapt to her death over the falls. This 1939 view shows the pristine beauty of these cascading falls.

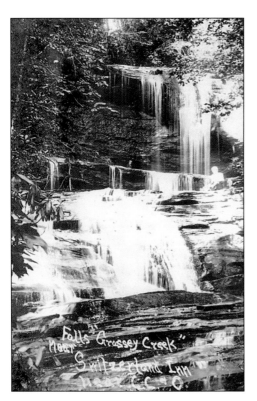

GRASSY CREEK FALLS. This *c.* 1913 view of Grassy Creek Falls nearly disguises the two men who stand and sit nearby to enjoy the power of the flowing water as it tumbles over the creek's rocky ledges. One man, wearing a cap, stands at the center of the second ledge from the top. The second man, seen only as a white silhouette, appears to be sitting at the far right-hand edge of the same ledge, just slightly below it on a rock table. These falls are located near Little Switzerland (3,500 feet), a resort community founded in 1910 in McDowell County, North Carolina.

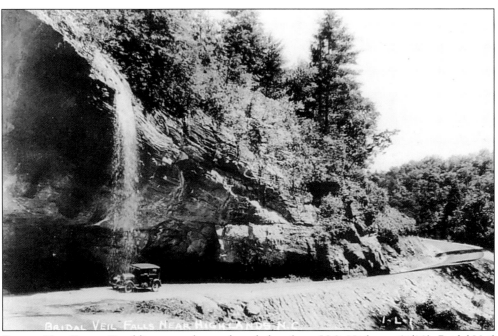

BRIDAL VEIL FALLS. Tumbling over the roadway below (now U.S. Highway 64/28), Bridal Veil Falls (120 feet high) is driven under by a vintage automobile. The falls are located in Macon County about two-and-a-half miles from Highlands, North Carolina. (Cline Photo.)

Five

THE BLUE
RIDGE PARKWAY

A 469-mile ribbon of pavement, running from the Shenandoah Valley in the north to the Great Smoky Mountains in the south, the Blue Ridge Parkway was a Depression-era project designed to give motoring visitors an amazing tour of the Blue Ridge Mountains. Highlighted by scenic overlooks, trails, and picnic and camping areas, the Blue Ridge Parkway is constructed from mountaintop to mountaintop along ridge lines wherever possible, affording the very best views to those who travel its length. The Parkway is closed to commercial vehicles, and speed limits are slow, allowing visitors to take in as much of the scenery as possible. Started in 1935, in part to create thousands of jobs for out-of-work U.S. citizens, the Parkway was completed in sections until the last link was connected in 1983 at Grandfather Mountain with the construction of the Linn Cove Viaduct, called the most complicated bridge ever built.

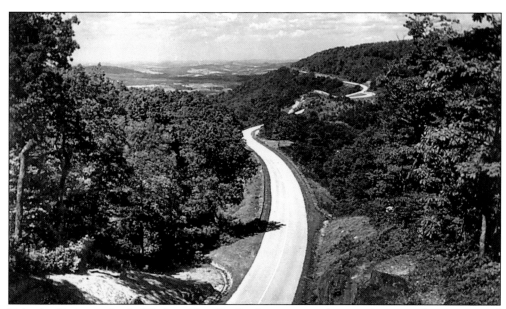

DEVIL'S GARDEN. At 3,428 feet, Devil's Garden, an area known for its rocky terrain and poisonous snakes, straddles the Blue Ridge Parkway as it winds its way along the border between Alexander and Wilkes County, North Carolina. (Cline Photo.)

51

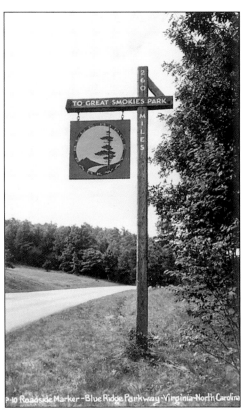

ROADSIDE MARKER. Standing some 260 miles from the Great Smoky Mountains National Park, this roadside sign is a familiar site to automobile travelers who have driven the twisting ribbon of pavement called the Blue Ridge Parkway. (Cline Photo.)

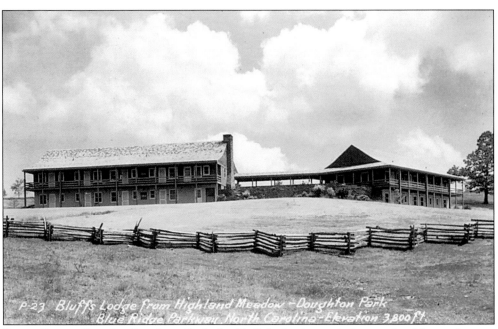

BLUFFS LODGE. Found in Doughton Park, the Bluffs Lodge is a typical example of the modest, yet comfortable lodging provided to Blue Ridge Parkway travelers. This view, taken from Highland Meadow, is at an elevation of 3,800 feet. (Cline Photo.)

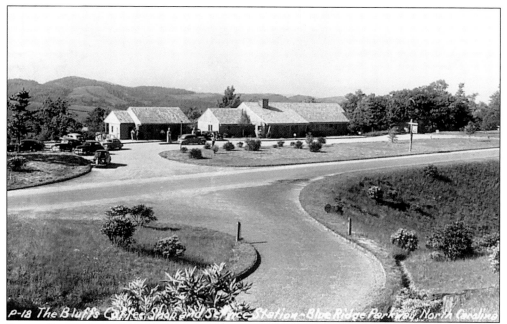

BLUFFS COFFEE SHOP. The Bluffs Coffee Shop and service station is an almost "must stop" venue for Blue Ridge Parkway travelers. Here, kids and adults alike can evacuate their cars for awhile to stretch stiff legs, rest scenic-view weary eyes, use restrooms, and fill both tank and tummy. (Cline Photo.)

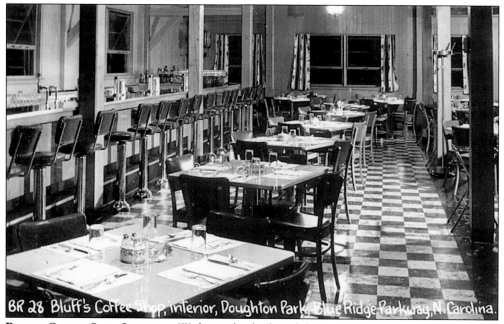

BLUFFS COFFEE SHOP INTERIOR. With its checkerboard floor, soda fountain, and neat tables, the Bluffs Coffee Shop is prepared for business in this early photo of one of the Blue Ridge Parkway's most recognized rest stops. (Cline Photo.)

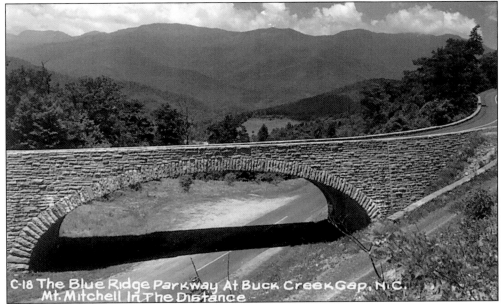

C-18 The Blue Ridge Parkway At Buck Creek Gap, N.C.
Mt. Mitchell In The Distance

BUCK CREEK GAP BRIDGE. Travelers' eyes are delighted by the magnificent handiwork and artistry of stonemasons who constructed miles of limestone rock walls and scores of bridges along the length of the Blue Ridge Parkway. This stunning example is located at Buck Creek Gap (3,200 feet) on the McDowell-Yancey County line. Mount Mitchell is seen on the horizon. (Cline Photo.)

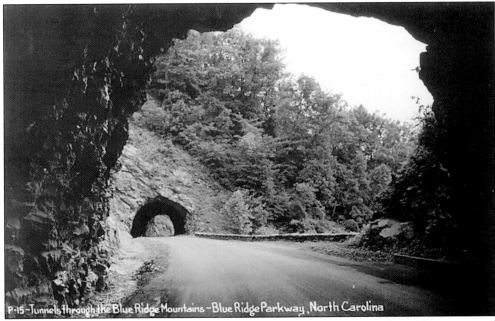

P-15-Tunnels through the Blue Ridge Mountains-Blue Ridge Parkway, North Carolina

TWIN TUNNELS. Traversing the Blue Ridge Mountains with the Blue Ridge Parkway required ingenuity, good engineering, and brute mechanical force. These twin tunnels, located near the Craggy Gardens section of the Parkway, were cut and blasted through the mountainside to make way for the roadway. This early view shows the tunnel walls before they were faced with cut stone in the style of parkway walls and bridges. (Cline Photo.)

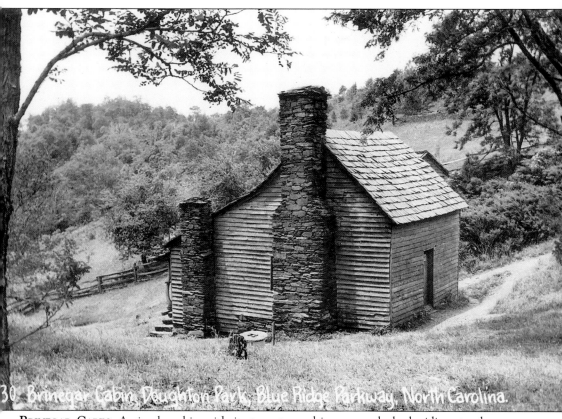

30 Brinegar Cabin, Doughton Park, Blue Ridge Parkway, North Carolina.

BRINEGAR CABIN. A simple cabin with its two stone chimneys and plank siding stands as a sentinel, reminding travelers on the Blue Ridge Parkway of days when rugged pioneers braved the wilderness and harsh climate of the mountains to carve out a new life for themselves and their families. Located at milepost 238.5 and open to the public today, the Brinegar Cabin was built by Martin Brinegar about 1880. It was sold to the Blue Ridge Parkway by Brinegar's widow in the 1930s. (Cline Photo.)

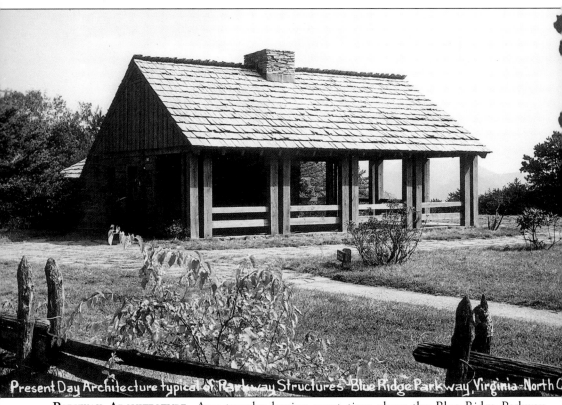

Present Day Architecture typical of Parkway Structures Blue Ridge Parkway, Virginia-North C

PARKWAY ARCHITECTURE. Any traveler having spent time along the Blue Ridge Parkway recognizes the distinctive architecture of structures, fences, and signs erected to accommodate them during their journey. This shelter, with its heavy posts, rustic style, shake roof, and stone chimney is typical of many structures visited along the way. The split-rail fence seen in the foreground represents the many miles of railing, originally made of chestnut, erected between public parkway land and the property of private land owners. (Cline Photo.)

Six

INNS, HOTELS, LODGES, AND CAMPS

Ranging from the sublime to the nearly ridiculous, tourist lodging in western North Carolina has taken nearly every form imaginable to accommodate the hoards of visitors traveling to the mountains each year. A family on a budget might tent camp its way along a stretch of the Blue Ridge Parkway, while a more affluent clientele might lodge itself at a posh hotel like Asheville's Grove Park Inn or at an equestrian dude ranch in a picturesque valley. But for those people in between these two extremes, there were modest inns, motels, and lodges dotted along every major highway leading to and through the state's mountains. In fact, it was the advent of vacations planned around automobile travel that gave rise to the creation of motels, a term derived from the words "motor hotel." Throughout the region, motels with as few as half a dozen rooms or as many as 100 rooms catered to vacation travelers, whose cars could be parked for the night just a few feet away from the door of their bedroom. Youth vacations were often spent in camps whose activities included cooking on campfires, horseback riding, tennis, hiking, boating, and handicrafts.

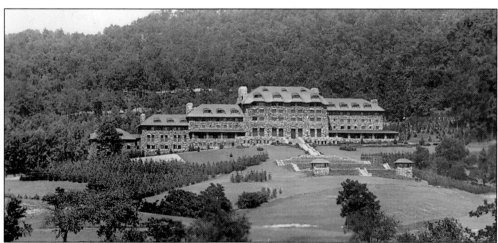

GROVE PARK INN. Today considered one of the nation's finest resort hotels, the Grove Park Inn was constructed in 1912 by Edwin W. Grove on scenic Sunset Mountain, near Asheville, North Carolina. Using native materials, including stones weighing as much as 10,000 pounds, Grove created an arts and crafts masterpiece that has delighted its guests for decades. (Photo by J.H. Howard, Asheville, North Carolina.)

57

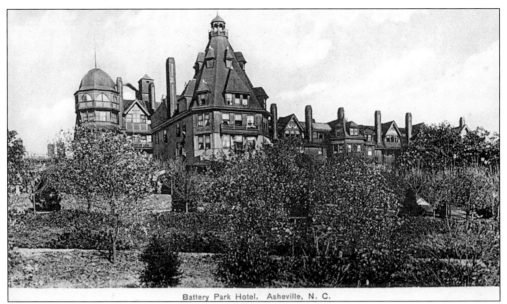

Battery Park Hotel. Asheville, N. C.

BATTERY PARK HOTEL. Opened July 12, 1886, Asheville's Battery Park Hotel was advertised this way: "The climate is as mild as Milan; the scenery is as grand as America affords. Only twenty-two hours from new York without change of cars. This hotel is the best equipped in the Southern States. Otis elevator; steam heat or fire-places in every room. Lighted by over one thousand electric incandescent lamps. Hot and cold porcelain baths, public and private, on every floor. . . . This hotel has near half a mile of piazzas, which are enclosed in glass during the winter. Besides this, there is a special sun bath piazza two hundred feet long outside the glass enclosure. These are advantages that are not possessed by any other resort in the South."

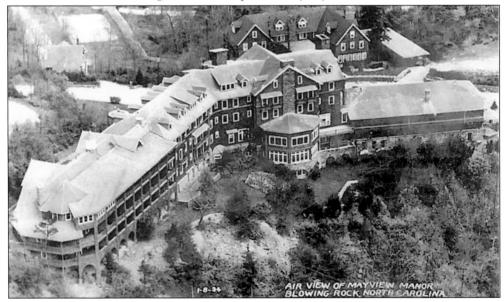

MAYVIEW MANOR. Built in Blowing Rock and opened in 1921, the Mayview Manor was a 138-room hotel constructed of chestnut wood and native fieldstone. Its exterior was covered with chestnut bark. Catering to an affluent clientele, the Mayview was known for its fine accommodations and entertainment.

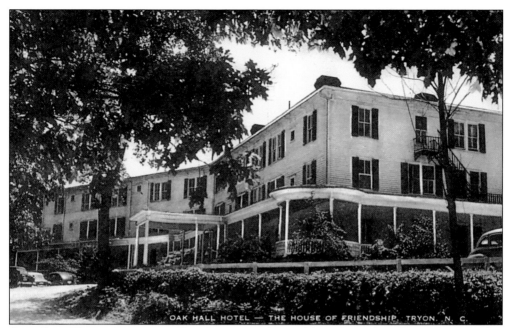

Oak Hall Hotel. Touting itself as the House of Friendship, the Oak Hall Hotel, situated in Tryon, North Carolina (1,075 feet), was where F. Scott Fitzgerald stayed when visiting Tryon. During his stay he wrote short stories and poems, spending some time at a local drug store's soda fountain. Tryon, with its scenery and clear mountain air, was a mecca for writers and artists in the early 20th century.

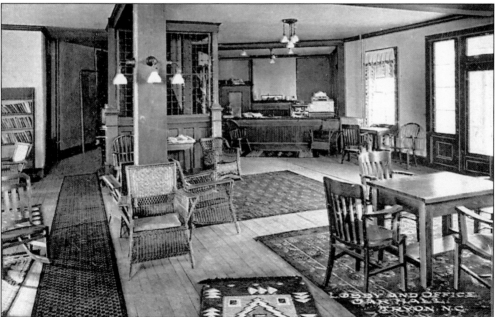

Oak Hall Interior. This view of the lobby and office for the Oak Hall Hotel suggests that it offered modest, but neat accommodations to its guests. One can imagine F. Scott Fitzgerald sauntering through the lobby hardly noticed by other guests. (Photo by Herbert W. Pelton, Asheville, North Carolina.)

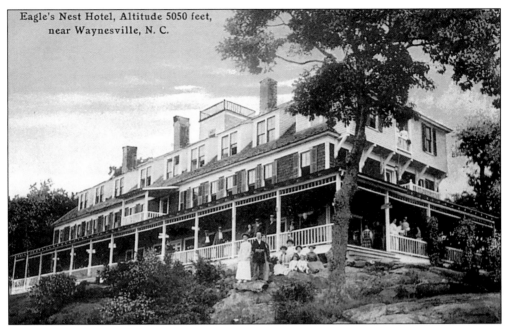

Eagle's Nest Hotel, Altitude 5050 feet, near Waynesville, N. C.

EAGLE'S NEST HOTEL. Built in 1900 on top of the Balsam Mountains by S.C. Satterthwait of Waynesville, the Eagle's Nest Hotel, at 5,050 feet in elevation, was promoted as a haven for hay-fever sufferers. Accommodating about 100 guests, rooms could be supplemented by tents.

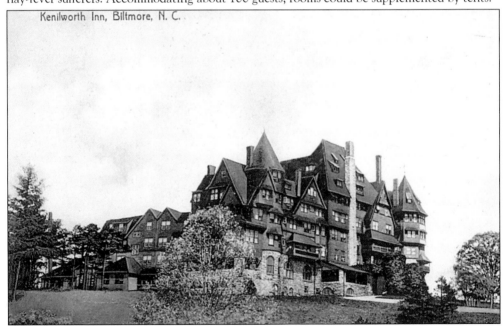

Kenilworth Inn, Biltmore, N. C.

KENILWORTH INN. Described as the coolest and most beautiful summer resort in America, the Kenilworth Inn boasted: "Pure water, the driest and most invigorating air, entire absence of mosquitoes and fog, surrounded by one hundred and sixty acres of beautifully wooded park, filled with rustic seats and Summer houses. Adjoins the far-famed park of Mr. Vanderbilt. Loveliest of rides and drives. The social centre of the South . . . The finest orchestra, best table, most courteous service. The only artesian wells in Asheville."

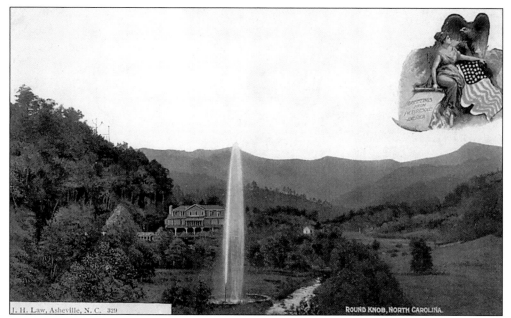

ROUND KNOB. Situated in McDowell County, Round Knob (3,500 feet) is the site of one of North Carolina's more unusual attractions, the Andrew's Geyser. Not a true geyser at all, but a 100-foot-tall fountain of water, it was built in the 1880s and later restored to honor Col. Alexander Boyd Andrews, builder of the Western North Carolina Railroad. Water from a mountain lake two miles away provided enough natural pressure to force the water up into its geyser-like plume. Trains once stopped at the site to allow passengers the opportunity to get a close up look at this remote mountain oddity.

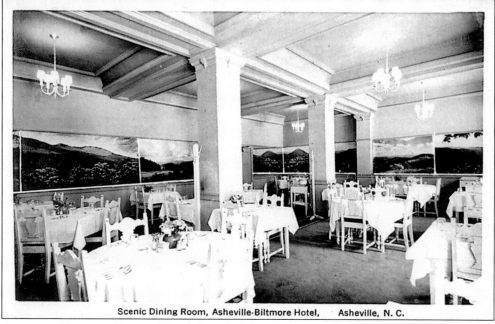

Scenic Dining Room, Asheville-Biltmore Hotel, Asheville, N. C.

ASHEVILLE-BILTMORE HOTEL. The Asheville-Biltmore Hotel offers 100 rooms, each with bath and circulating ice water.

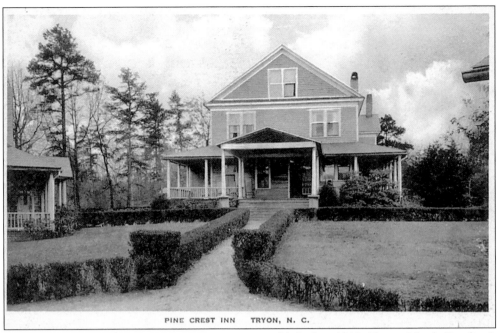

PINE CREST INN. Welcoming guests since it was established in 1917, Tryon, North Carolina's Pine Crest Inn was first owned and operated by equestrian Carter Brown.

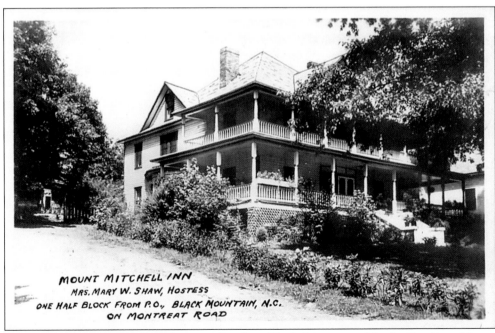

MOUNT MITCHELL INN. On Montreat Road in Black Mountain, North Carolina, Mount Mitchell Inn is operated by hostess Mary W. Shaw.

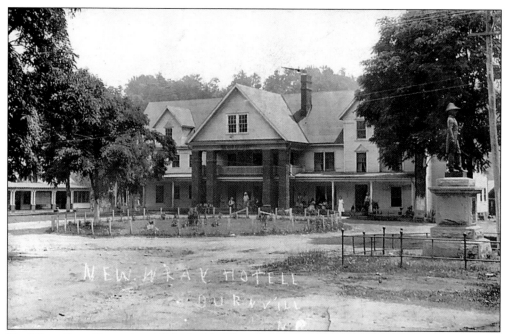

NU WRAY INN. Opened in 1833, the Nu Wray Inn is the oldest continuously operating inn in western North Carolina. It features guest rooms and fireside dining and is located on the town square in Burnsville, North Carolina.

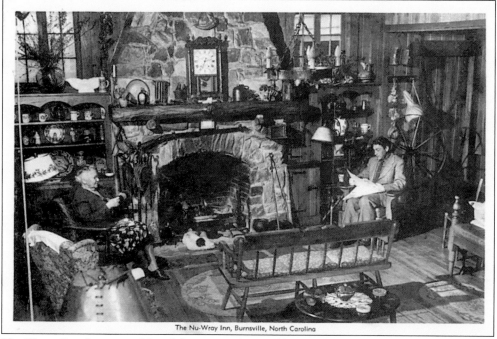

The Nu-Wray Inn, Burnsville, North Carolina

NU WRAY INN INTERIOR. Noted for its comfort and hospitality, the Nu Wray Inn welcomes its winter guests with the warmth of a crackling fire and the colors and textures of many handmade crafts.

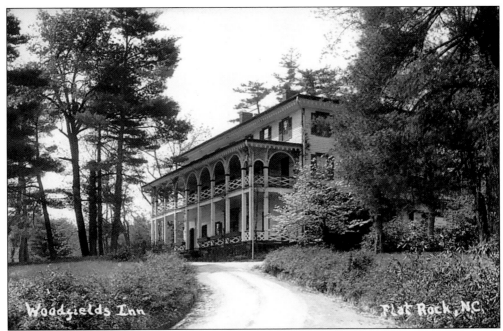

WOODFIELDS INN. A grand looking structure with its upper and lower verandas, the Woodfields Inn is located in Flat Rock, North Carolina (2,207 feet), home of the Flat Rock Playhouse and the site of poet Carl Sandburg's home of 22 years, Connemara.

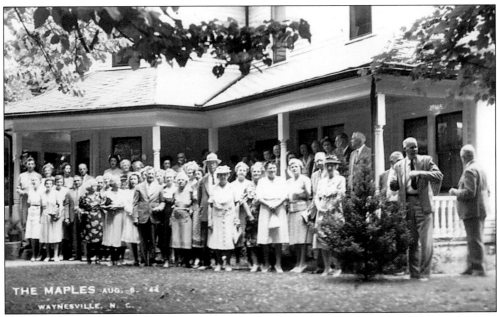

THE MAPLES. Perhaps the gathering point for a family or class reunion, the Maples, a homey-looking place found in Waynesville, North Carolina, hosts a large crowd of hatted ladies and suited men in this 1944 photograph.

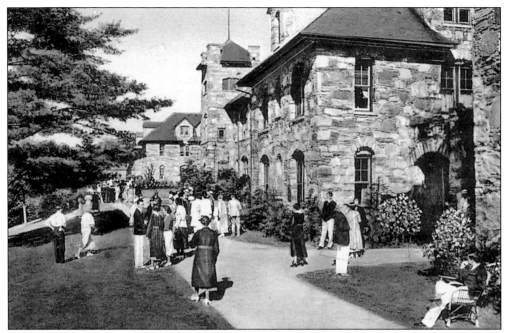

PINNACLE INN. At 4,000 feet elevation, the Pinnacle Inn offers lodging in the Tennessee, North Carolina, and Virginia Halls at Lees-McRae College in Banner Elk, North Carolina. During winter months these buildings are occupied by college students.

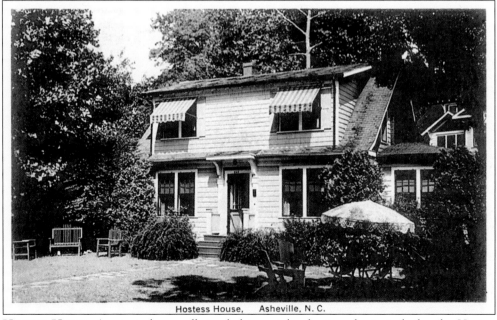

Hostess House, Asheville, N. C.

HOSTESS HOUSE. A private home offering lodging, stoker heat, and private baths, the Hostess House is located on Merrimon Avenue in Asheville and is operated by Mrs. Anne Tyndale-Lea.

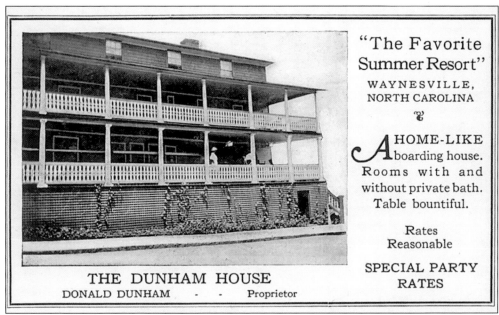

THE DUNHAM HOUSE. "The Favorite Summer Resort" in Waynesville, North Carolina, the Dunham House, operated by proprietor Donald Dunham, offers a home-like boarding house featuring reasonable rates, a bountiful table, and rooms with or without private baths.

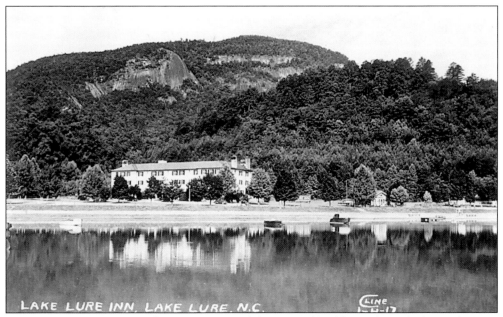

LAKE LURE INN. Constructed in 1927 as one of the original buildings planned when Lake Lure was built in the Hickory Nut Gorge, the Lake Lure Inn accommodates visitors to Chimney Rock Park and the nearby towns of Lake Lure (1,050 feet), Bat Cave (1,250 feet), and Gerton. (Cline Photo.)

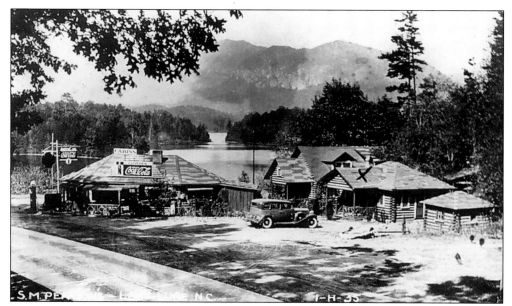

S.M. PEARSON'S. This intriguing view of Lake Lure and the mountains surrounding it shows a truly picturesque travelers' rest. The buildings associated with S.M. Pearson's place are made of notched pole logs and multicolored shingle roofs. Cabins of various sizes can be seen, and the one occupied by the sender of this card is marked with an "X" on the roof. The store next door features groceries, lunches, and gasoline. The sender's inscription on the card reads: "You would sure love these cabins and the view from here is considered finest in Blue Ridge Mts Lake is 3 miles long Cabins are made of burnt pine darling lanterns and bath room." The card is postmarked 1940. (Cline Photo.)

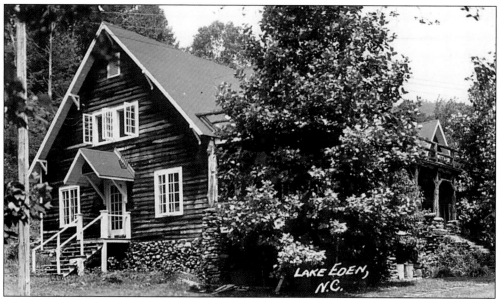

LAKE EDEN. This Lake Eden cottage is located on the site of what was once Black Mountain College (established in 1933), an experimental school following John Rice's educational theories combining liberal arts with the fine arts. The college attracted numerous talented artists, musicians, and writers.

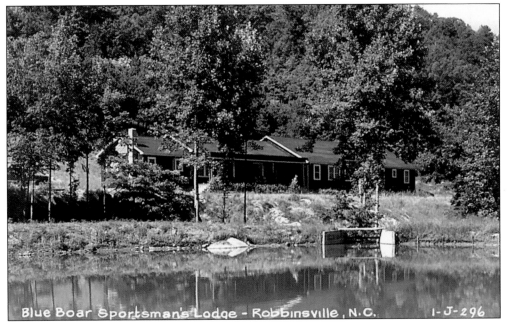

Blue Boar Sportsman's Lodge - Robbinsville, N.C. 1-J-296

BLUE BOAR SPORTSMAN'S LODGE. In about 1912, a shipment of European wild hogs was brought to the Snowbird Mountains to a 500-acre hog lot on Hooper Bald (5,400 feet) near the Tennessee–North Carolina line. Some stayed in the pen, but many escaped. Through the years, the descendants of these wild hogs have proliferated in the area. In 1950, Fred Bruckmann, owner of Bruckmann Brewery in Cincinnati, Ohio, built the Blue Boar Lodge, named for the wild hogs roaming the forests around it. Both bear and wild boar hunts were organized from the lodge, located about ten miles from Robbinsville, North Carolina. (Cline Photo.)

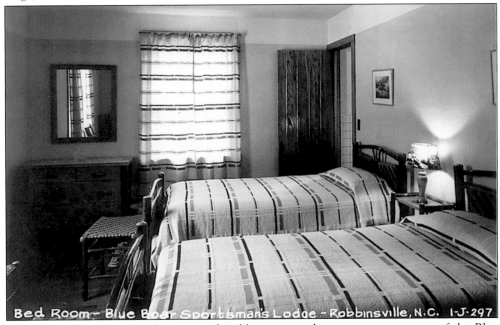

Bed Room - Blue Boar Sportsman's Lodge - Robbinsville, N.C. 1-J-297

BLUE BOAR BEDROOM. Simple, yet comfortable accommodations greet occupants of the Blue Boar Sportsman's Lodge. (Cline Photo.)

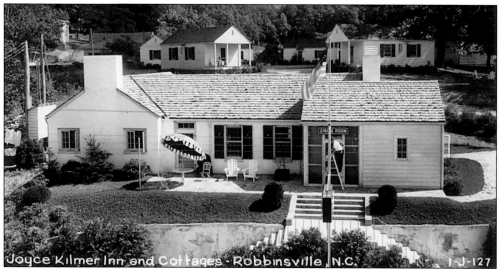

JOYCE KILMER INN. Featuring a fine dining room and several cabins, the Joyce Kilmer Inn was started around 1938–1939 as part of a business venture called Cheoah Enterprises. Located in Robbinsville, North Carolina (2,150 feet), the name comes from the name of Joyce Kilmer (1886–1918), author of the poem "Trees." (Cline Photo.)

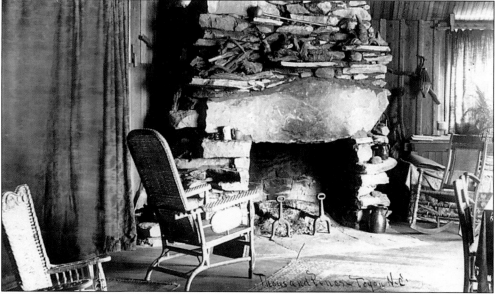

THOUSAND PINES. Some travelers were fortunate to be the guests of residents of western North Carolina. This view shows the fireplace and interior of Thousand Pines in Tryon (1,075 feet), the home of the playwright and actor William Gillette (Sherlock Holmes). Tryon was a haven for artists early in the 20th century, including New England watercolorist Amelia Watson. Gillette was her patron. Photographer Margaret Morley was a friend as well. An inscription on the back of this photo reads: "After showing us a room where Mr. Gillett sometimes sleeps he said, pointing to the books on the shelves—these books are mine—The table was set for tea with striped red tablecloth—red flowered dishes. The daughter had fire made in grate and said now sit down in the rocker so that you can say that you have sat beside water colors by Amelia Watson of Hartford, Conn. views." (Photo attributed to Margaret Morley.)

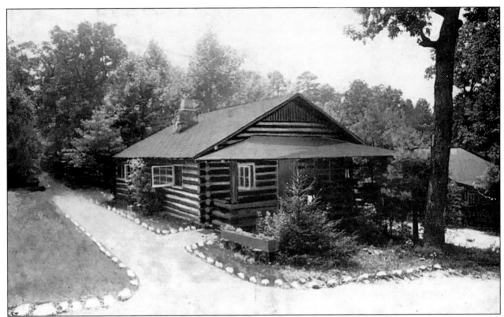

HOMELAND PARK COTTAGES. Found near Asheville on U.S. Highway 70, Homeland Park Cottages offers 70 modern rustic cottages, a dining room, gift shop, and grill.

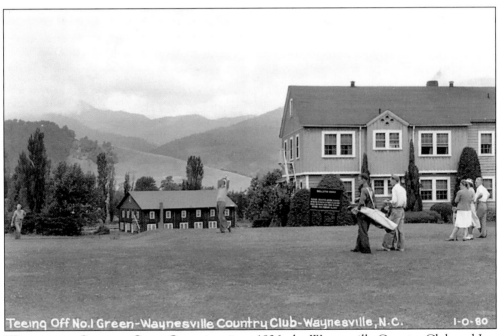

Teeing Off No.1 Green-Waynesville Country Club-Waynesville, N.C. 1-0-80

WAYNESVILLE COUNTRY CLUB. Operating since 1926, the Waynesville Country Club and Inn was built on the fields of a former dairy farm. The dairy barn served as the first clubhouse, complete with dance hall and card room upstairs. (Cline Photo.)

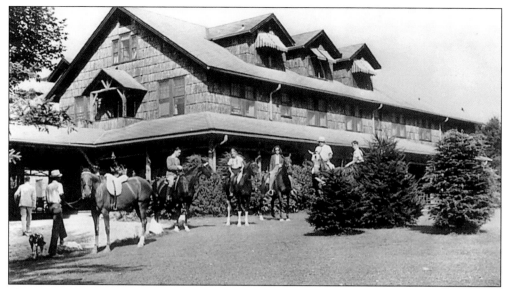

HIGH HAMPTON INN. Beginning first as the site of a hunting lodge built by Wade Hampton III (1818–1902), at the time one of the wealthiest men in the South and also a Confederate general and governor of South Carolina, the High Hampton Inn and its predecessor buildings have served guests for more than a century and a half. Located in Cashiers, North Carolina, the original hunting lodge, inn, and the Halsted cottage were completely destroyed by a 1932 fire. A new inn, built on the site of the Hampton Hunting Lodge, was completed in 1933. It had three stories, a large four-sided fireplace, and the outside was covered with weather and insect resistant chestnut tree bark. The inn gained its High Hampton name following the purchase by Dr. William Stewart Halsted, who married the niece of Wade Hampton III, Caroline Hampton, in 1890. (Cline Photo.)

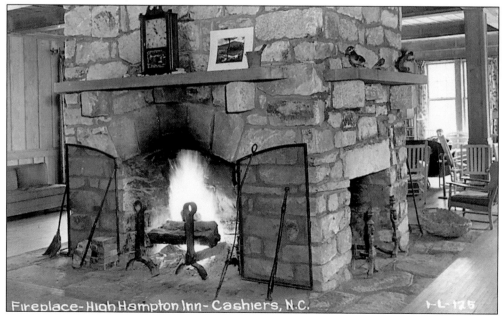

FIREPLACE, HIGH HAMPTON INN. A hot fire blazes in the magnificently crafted four-sided fireplace located in the High Hampton Inn in Cashiers, North Carolina. (Cline Photo.)

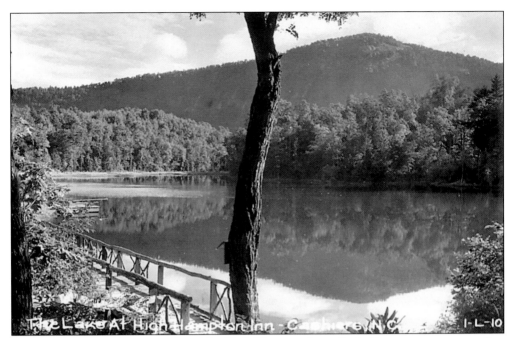

THE LAKE AT HIGH HAMPTON INN. The High Hampton Inn afforded its guests an outstanding scenic view across a lake toward a nearby mountain. (Cline Photo.)

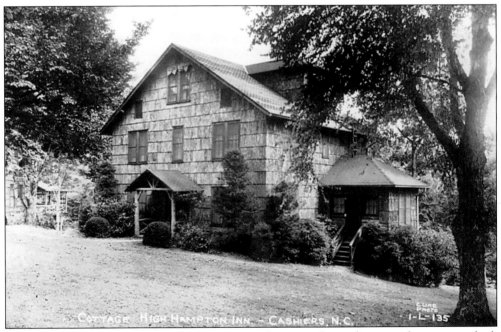

COTTAGE, HIGH HAMPTON INN. A rustic, yet ample cottage bears the same chestnut tree bark that covers and protects the High Hampton Inn from rough mountain weather and summer insects. (Cline Photo.)

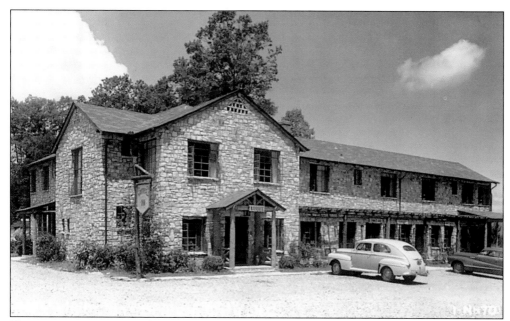

NANTAHALA INN. Located on Fontana Lake, about nine miles west of Bryson City, North Carolina (1,736 feet), the Nantahala Inn is constructed of beautifully cut stone and timbers cut from nearby forests. The inn is a welcome respite for motorists who have ventured to the far reaches of the mountains and the state. (Cline Photo.)

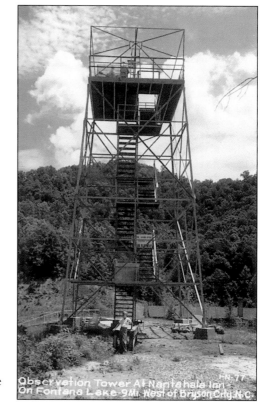

OBSERVATION TOWER, NANTAHALA INN. When visiting the mountains, finding the best scenic view is the ultimate quest for some. To aid its guests in reaching this goal, the Nantahala Inn erected a steel observation tower nearby. Two guests sit on top as a young boy waits at the base of the tower, perhaps mustering his courage to make the ascent himself. (Cline Photo.)

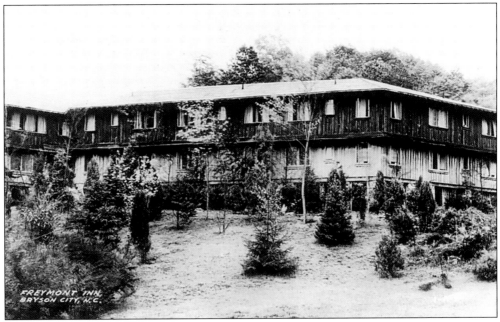

FREYMONT INN. Constructed in 1923 by lumber magnate Amos Frye, the Freymont Inn was built of the finest chestnut, oak, and maple to be found in the surrounding forests. The exterior was covered with bark from huge poplar trees. The inn is situated near the Great Smoky Mountains National Park at Bryson City, North Carolina (1,736 feet). (Cline Photo.)

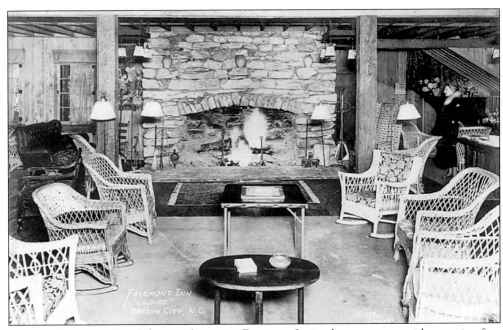

LOUNGE, FREYMONT INN. The cozy lounge at Freymont Inn welcomes guests with a roaring fire, rocking chairs, and handmade North Carolina art pottery for decoration. (Cline Photo.)

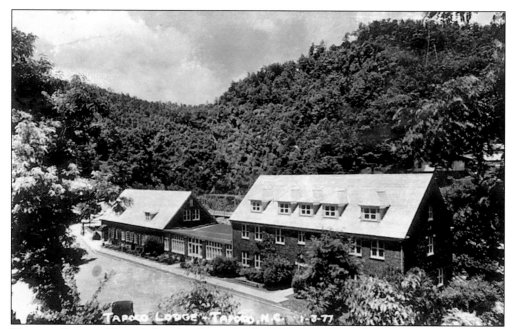

TAPOCO LODGE. Named for the first two letters of each word of the Tallassee Power Company, Tapoco Lodge was completed in 1930. Later, seven cottages were added. Nearby, the Cheoah Dam was built on the Cheoah River to create hydroelectric power for the production of aluminum. Tapoco Lodge is located near Robbinsville, North Carolina (2,150 feet). (Cline Photo.)

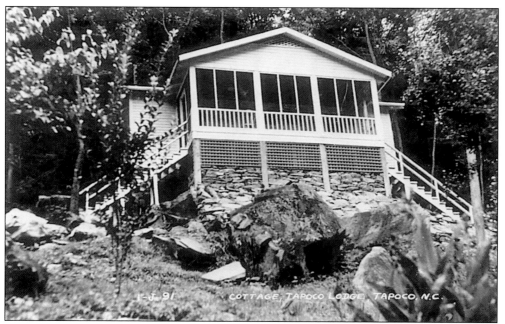

COTTAGE, TAPOCO LODGE. This view shows one of seven cottages constructed to expand the occupancy of the Tapoco Lodge. (Cline Photo.)

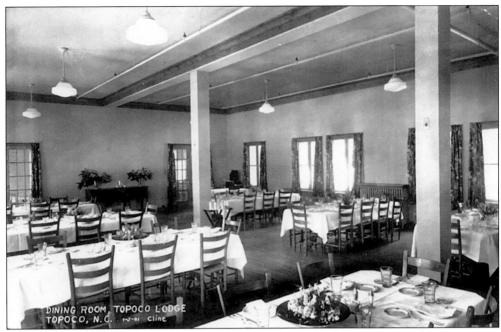

DINING ROOM, TAPOCO LODGE. White tablecloths, china, and flowers adorn the dining room at Tapoco Lodge. (Cline Photo.)

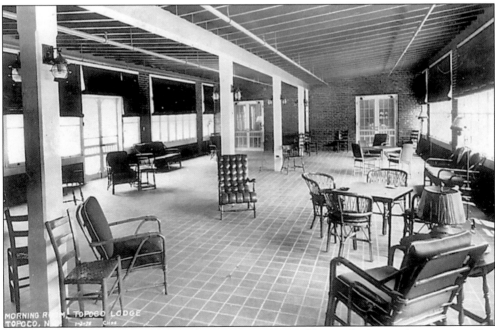

MORNING ROOM, TAPOCO LODGE. The morning room at Tapoco Lodge, with its surrounding windows, tile floor, and comfortable seating, seems a pleasant place to begin a day in the mountains. (Cline Photo.)

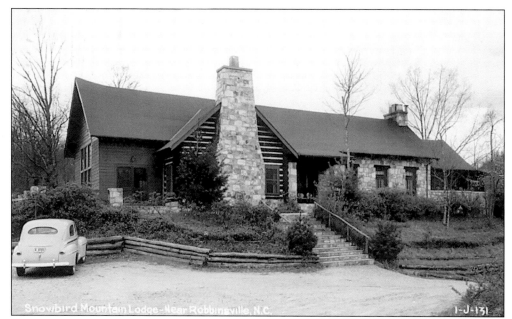

SNOWBIRD MOUNTAIN LODGE. Built in 1940 and opened to the public in 1941, Snowbird Mountain Lodge, located near Robbinsville, North Carolina (2,150 feet), was first owned by Arthur and Edwin Wolfe. The lodge, designed by an Asheville architect and furnished by a Chicago decorator who designed the lounge furniture, dining room chairs, and drapes, included rooms paneled in different woods and two large fireplaces. (Cline Photo.)

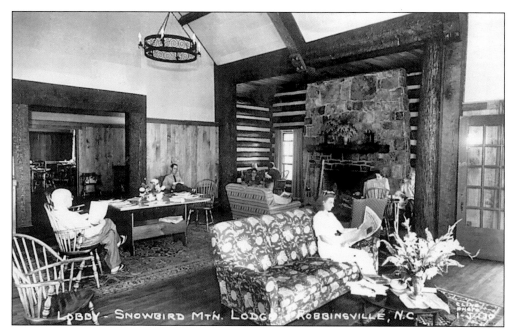

LOBBY, SNOWBIRD MOUNTAIN LODGE. Guests relax in the Snowbird Mountain Lodge lobby. The room, with its exposed beam ceiling, wrought iron lighting, stone fireplace, wood paneling and floors, and log walls, exudes a warm atmosphere and feeling of hospitality. (Cline Photo.)

77

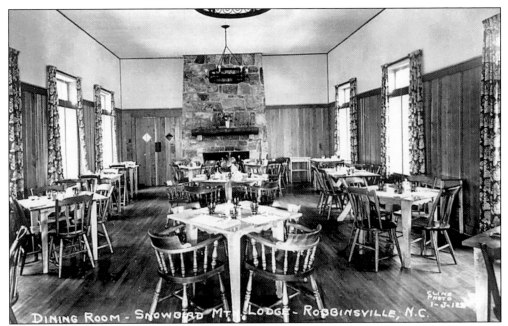

DINING ROOM, SNOWBIRD MOUNTAIN LODGE. Tended to by a massive fireplace at one end, the Snowbird Mountain Lodge dining room seems a good place to gather with family and friends to begin or end a day of mountain adventure. (Cline Photo.)

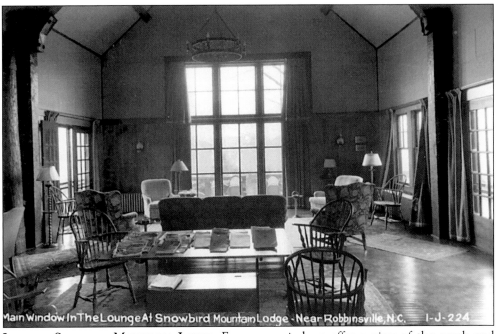

LOUNGE, SNOWBIRD MOUNTAIN LODGE. Enormous windows offer a view of the porch and mountains from the Snowbird Mountain Lodge lounge. (Cline Photo.)

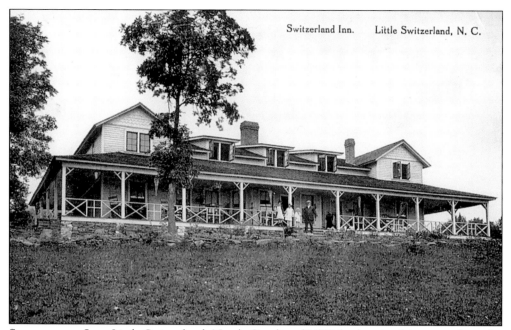

SWITZERLAND INN. Little Switzerland, North Carolina (3,500 feet), gained its name from the incredible panoramic views of mountains and valleys surrounding it, reminding its founders of the Swiss Alps. Formed as a summer resort in 1910 by Heriot Clarkson, the inn is located in McDowell County on the head of Threemile Creek.

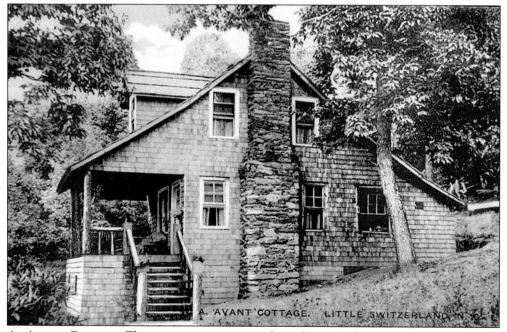

A. AVANT COTTAGE. This attractive cottage, with its dry-stacked stone chimney and wood-shingled siding, is located in Little Switzerland, North Carolina.

79

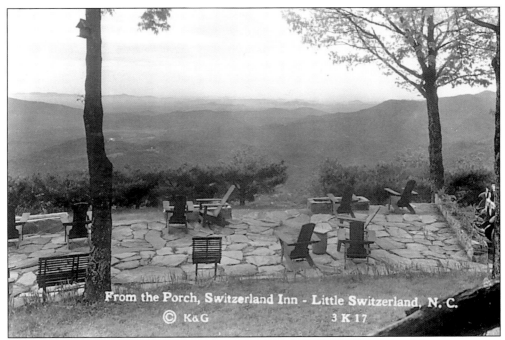

FROM THE PORCH, SWITZERLAND INN. From the porch at Little Switzerland Inn, panoramic views can be enjoyed by guests for hours on end. (K&G Photo.)

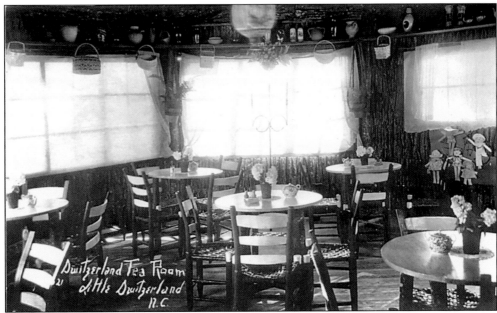

TEA ROOM, SWITZERLAND INN. Common to many inns and lodges in the Blue Ridge Mountains are the many handmade crafts used for decoration and for sale to guests. This photograph of the Switzerland Inn tea room displays cloth dolls, woven baskets—some of which appear to be made by Cherokee Indians—and an array of Hilton art pottery made by a family of potters located in the nearby foothills of the Blue Ridge. Chairs appear to be handmade of both dark and light native woods grown in the area.

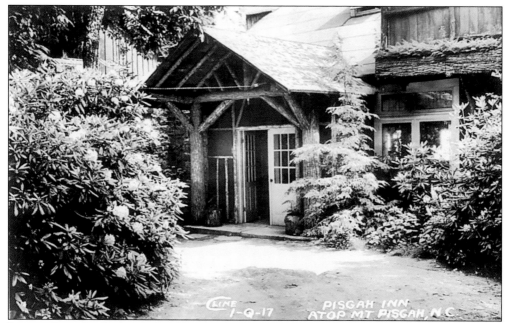

PISGAH INN. Perched on top of Mount Pisgah (5,721 feet), the original Pisgah Inn opened about 1919. Its rustic charm and grand natural landscaping, evidenced in this photograph by the abundance of evergreen rhododendrons in bloom, was a treat for work-weary travelers who ventured to its mountaintop location for rest and recreation. (Cline Photo.)

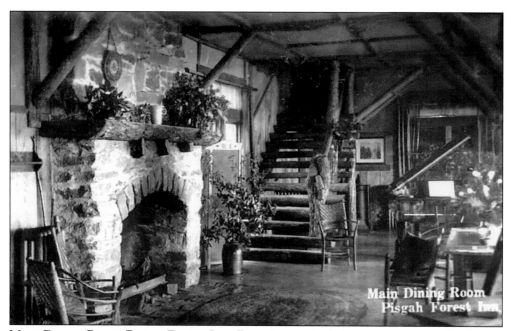

MAIN DINING ROOM, PISGAH FOREST INN. Featuring rustic chairs, a massive stone fireplace, a timber framed roof, and a grand piano, the main dining room of the Pisgah Forest Inn exudes an atmosphere of warmth and comfort to its guests.

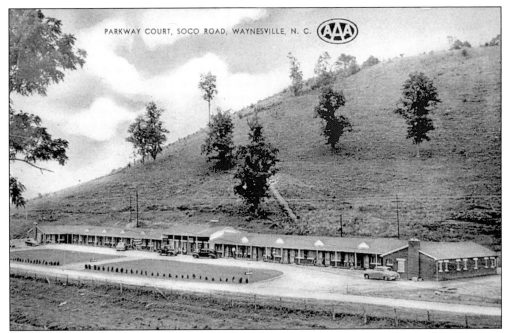

PARKWAY COURT. Offering 30 units with tile baths, the Parkway Court is located on U.S. Highway 19, one mile west of Lake Junaluska and three miles from Waynesville, North Carolina.

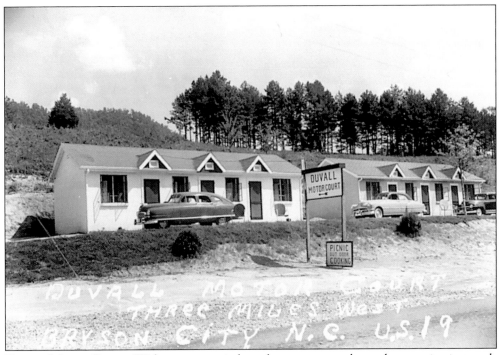

DUVALL MOTOR COURT. With casement windows thrown open to the cool mountain air, travel-worn cars parked outside, and springy metal lawn chairs poised for evening highway viewing, tourists rest inside the Duvall Motor Court, located three miles west of Bryson City, North Carolina (1,736 feet), on U.S. Highway 19. Picnics and outdoor cooking are allowed here.

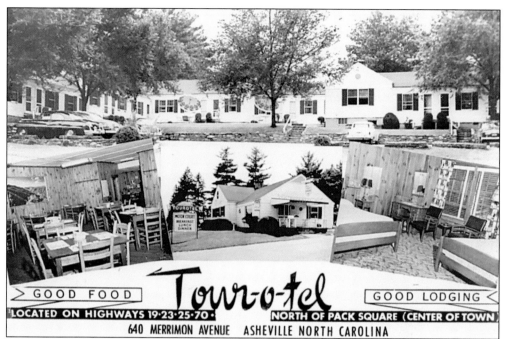

TOUR-O-TEL. Asheville's Tour-O-Tel offers good food and good lodging on Merrimon Avenue, just north of Pack Square in the center of town.

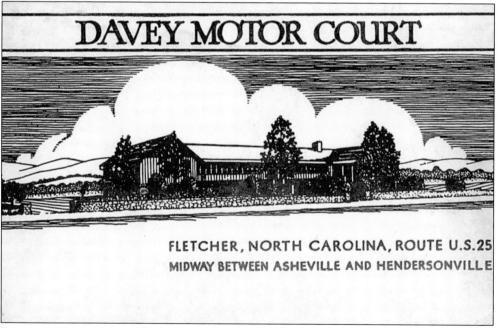

DAVEY MOTOR COURT. Found on U.S. Highway 25 at Fletcher, between Asheville and Hendersonville, North Carolina, the Davey Motor Court offers "A truly luxurious motor court, centrally located for motor trips to the scenic wonders of the Great Smokies. Artistically decorated rooms, each with bath. Delicious meals served in our immaculate restaurant. Highly recommended by Duncan Hines."

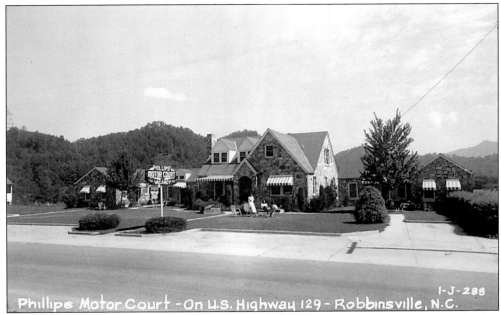

Phillips Motor Court - On U.S. Highway 129 - Robbinsville, N.C.

PHILLIPS MOTOR COURT. Robbinsville's Phillip's Motor Court entices tourists with this promotion: "Take your meals in air-conditioned comfort at Phillip's Cafe, where you are welcome, and fill your car with gas at our Pure Oil Station where you are appreciated. Court accommodation with or without kitchenette and with or without Air-Conditioning." (Cline Photo.)

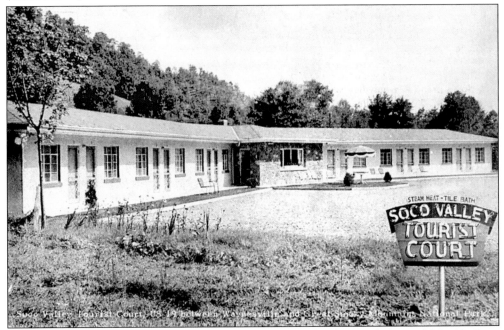

SOCO VALLEY TOURIST COURT. Located six miles west of Lake Junaluska on U.S. 19, Soco Gap Road, near Waynesville, North Carolina, the Soco Valley Tourist Court offers clean, comfortably cool rooms only a short drive to Mountainside Theatre, site of the Cherokee Indian drama *Unto These Hills*.

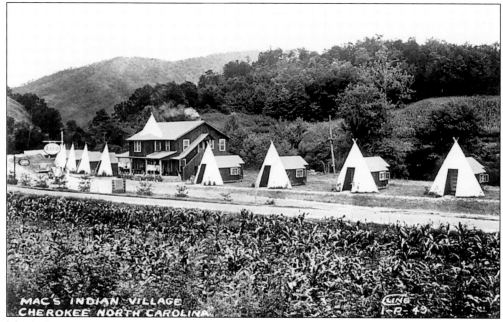

MAC'S INDIAN VILLAGE. Among the more unique lodging venues in western North Carolina, Mac's Indian Village, near Cherokee, North Carolina, provided cabin facilities, each with its own teepee entrance. (Cline Photo.)

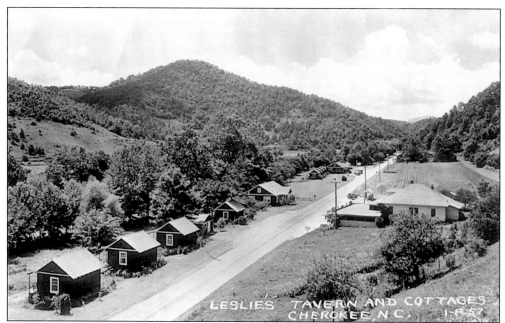

LESLIE'S TAVERN AND COTTAGES. One of many Cherokee area lodgings, Leslie's Tavern and Cottages offers easy access and all the services the motoring tourist needs for an overnight stay. (Cline Photo.)

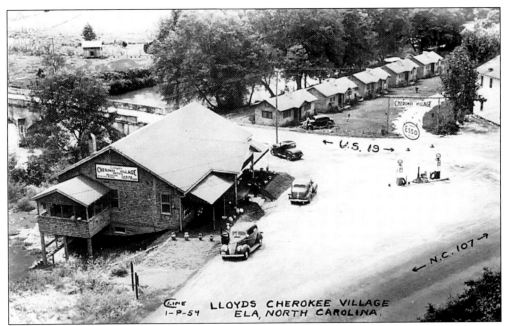

LLOYD'S CHEROKEE VILLAGE. Found at the intersection of U.S. Highway 19 and N.C. Highway 107 at Ela, North Carolina (1,830 feet), Lloyd's Cherokee Village provides cabins, Esso gasoline, a dining room, and a craft shop. The large pottery vases standing around the front porches of the main building are Piedmont-made art pottery vessels shipped to Cherokee and other mountain venues for sale to tourists. (Cline Photo.)

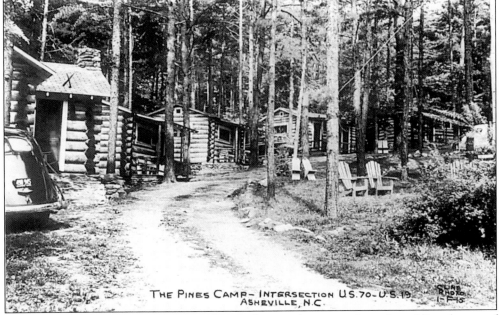

THE PINES CAMP. Mountain accommodations for travelers range from the sublime luxury of Asheville hotels, such as the Kenilworth and Battery Park, to the crude and rustic log pole cabins at a site like the Pines Camp, found at the intersection of U.S. Highway 70 and U.S. Highway 19 near Asheville. (Cline Photo.)

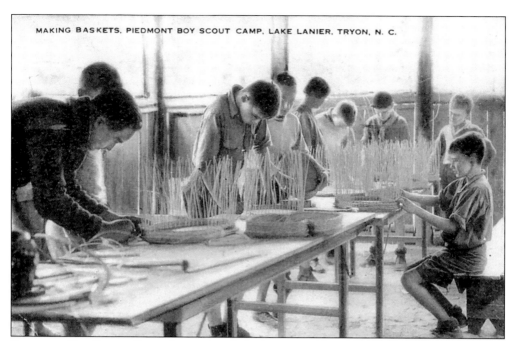

MAKING BASKETS, PIEDMONT BOY SCOUT CAMP, LAKE LANIER, TRYON, N. C.

Piedmont Boy Scout Camp. Located on Lake Lanier, at Tryon, North Carolina (1,075 feet), Piedmont Boy Scout Camp is host to boys for summer activities and crafts. These boys are making baskets. Dated 1935, the card bears the following inscription: "I am having a fine time up here. Please have my choclate sherbet ready Saturday. I hope you are not worrying about me. Love, James."

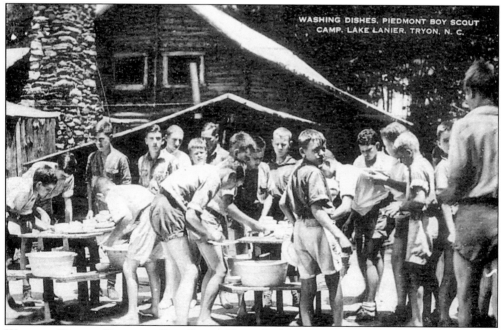

WASHING DISHES, PIEDMONT BOY SCOUT CAMP, LAKE LANIER, TRYON, N. C.

Washing Dishes, Piedmont Boy Scout Camp. Perhaps to impress upon his parents that not all of camp is fun and play, young James, the sender of this card in 1937, chose a scene depicting vigorous dishwashing activity at Piedmont Boy Scout Camp.

FOUR HORSEMEN FROM MONDAMIN — READING FROM LEFT TO RIGHT, NANCY ANN; CHICK CRAWFORD; HIGH-POCKET; HAWKEYE GEITNER. MONDAMIN-TAWASENTHA, TUXEDO, N. C.

CAMP MONDAMIN. Located in Tuxedo, North Carolina (2,187 feet), Camp Mondamin is a traditional residential camp for boys established in 1922. This photograph exhibits the so-called Four Horsemen from Mondamin, from left to right, as follows: Nancy Ann; Chick Crawford; Highpocket; Hawkeye Geitner.

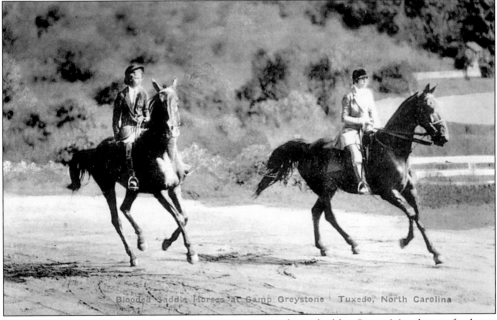

Blooded Saddle Horses at Camp Greystone — Tuxedo, North Carolina

CAMP GREYSTONE. Camp Greystone, a summer camp for girls, like Camp Mondamin for boys, is located near the town of Tuxedo on Lake Edith. Here, two young women ride blooded saddle horses on the camp's track.

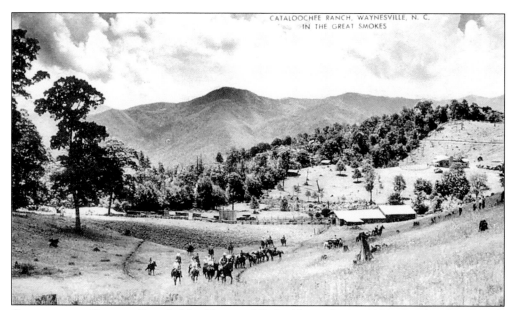

CATALOOCHEE RANCH. Founded by Tom and Judy Alexander in 1933, Cataloochee Ranch was first located in the Cataloochee Valley in the Great Smoky Mountains National Park. Excessive restrictions placed on use of the Smoky Mountains National Park location led the ranch to relocate in 1938 to property purchased from the "Potato King" of Haywood County, Verlin Campbell. Here, horseback riders travel through open meadows in the shadow of the magnificent mountain ridges surrounding them. (Asheville Post Card Company.)

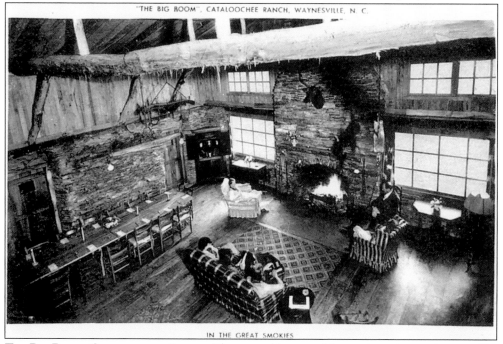

"THE BIG ROOM", CATALOOCHEE RANCH, WAYNESVILLE, N. C.

IN THE GREAT SMOKIES

THE BIG ROOM, CATALOOCHEE RANCH. The natural beauty of the outdoors is complemented by the rustic, yet comfortable surroundings indoors, as seen here in this view of the Big Room at Cataloochee Ranch. (Asheville Post Card Company.)

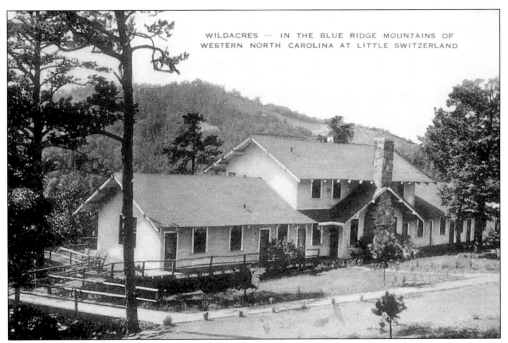

WILDACRES. Located in the Blue Ridge Mountains near Little Switzerland, North Carolina, Wildacres is a 1,400-acre estate owned by Mr. and Mrs I.D. Blumenthal and dedicated to the betterment of human relations and inter-faith amity.

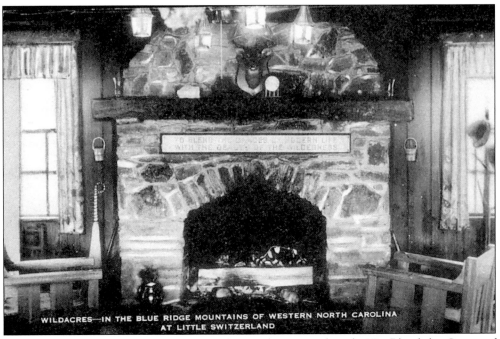

FIREPLACE, WILDACRES. The panel below the fireplace mantel reads: "To Blend the Graces of Modern Life with the Beauty of the Wilderness."

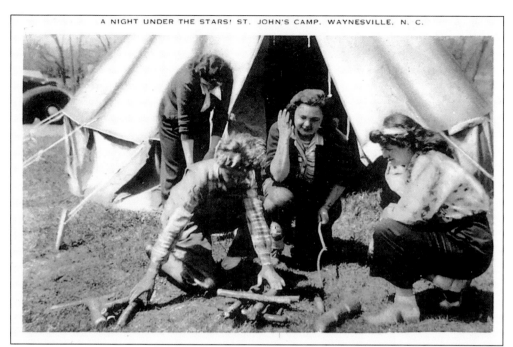

ST. JOHN'S CAMP. These young women practice their campfire building skills outside their canvas tent in this scene from Waynesville's St. John's Camp.

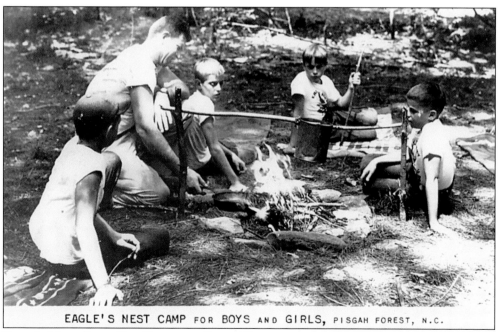

EAGLE'S NEST CAMP FOR BOYS AND GIRLS, PISGAH FOREST, N.C.

EAGLE'S NEST CAMP FOR BOYS AND GIRLS. The aroma of sizzling bacon cooking in an iron frying pan over an open campfire forms memories of camping in the mountains of North Carolina never forgotten. These young boys with their adult counselor enjoy a summer morning at Eagle's Nest Camp for Boys and Girls, located at Pisgah Forest, a community in Transylvania County, North Carolina.

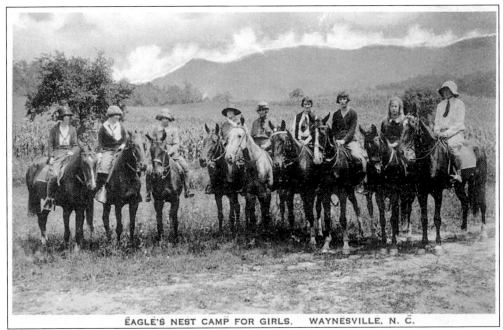

EAGLE'S NEST CAMP FOR GIRLS. WAYNESVILLE, N. C.

EAGLE'S NEST CAMP FOR GIRLS. One of western North Carolina's numerous camps hosting the children of America's more prosperous families, Eagle's Nest Camp for Girls provided equestrian activities for these young women. Eagle's Nest was located near Waynesville, North Carolina.

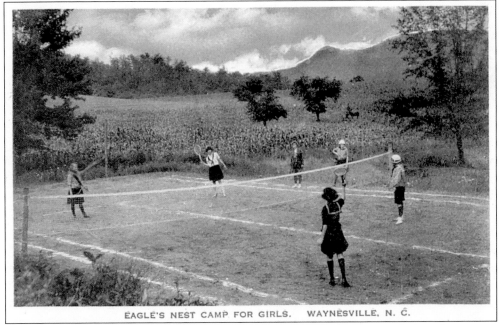

EAGLE'S NEST CAMP FOR GIRLS. WAYNESVILLE, N. C.

EAGLE'S NEST CAMP FOR GIRLS. Whether it is tennis or badminton they are playing, these young women residents of Eagle's Nest Camp are focused on the game. Fresh air and cool temperatures, combined with grand scenic views, add to the comradery of a summer with friends at camp.

Seven

Handmade Crafts

Native Cherokee people and early settlers of western North Carolina made almost everything utilized in the home by hand. It was an ordinary and necessary task to do so. This includes the fabrication of children's toys, clothing, coverlets, quilts, furniture, metal cooking implements, pottery, woodenware for kitchen use, farm tools, guns and other weapons for hunting, and many other items. Apart from their utilitarian function, these items were often embellished in shape or design in ways that demonstrate their makers' aesthetic sensibilities as well. A quilt top might take on one of dozens of possible patterns. A coverlet becomes the canvas upon which its weaver paints myriad designs with a naturally dyed palette of colored thread. A butter mold is carved by its maker with intricate designs that are repeatedly transferred to freshly churned butter every time its cavity is filled. The demand for vacation souvenirs and the need for cash income for mountain residents led to a handicraft movement aimed at satisfying both of these purposes. Extant handicraft practices were adapted to meet the demands of the tourism market; lost, or nearly lost, craft techniques were revived to create a broad range of offerings to those anxious to leave their money behind in the hills of the Blue Ridge.

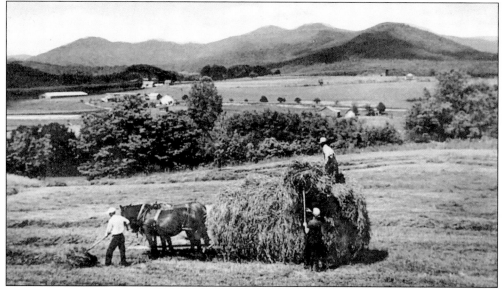

JOHN C. CAMPBELL FOLK SCHOOL. Established in 1925 by Olive Dame Campbell and Marguerite Butler Bilstrup in the form of Danish folk schools, John C. Campbell Folk School, located at Brasstown, North Carolina (1,650 feet), encouraged the preservation of Appalachian folk craft. The school, attracting vacationers and students from around the world, is located on a 175-acre farm.

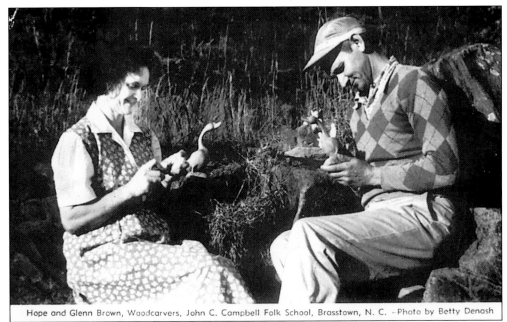

Hope and Glenn Brown, Woodcarvers, John C. Campbell Folk School, Brasstown, N. C. -Photo by Betty Denosh

BRASSTOWN CARVERS. Hope and Glenn Brown, noted woodcarvers who are part of the group of artisans called the Brasstown Carvers, demonstrate their skill at using carving knives and native woods to fashion animals and other figures of various sorts. The Brasstown Carvers are an outgrowth of the woodcarving programs at John C. Campbell Folk School.

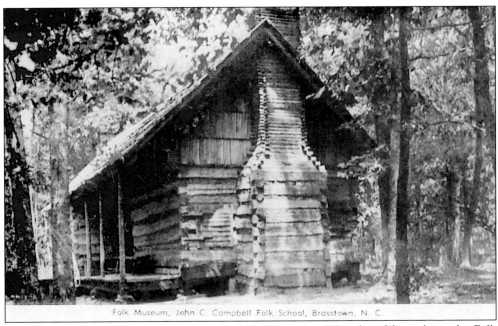

Folk Museum, John C. Campbell Folk School, Brasstown, N. C.

FOLK MUSEUM. Raised by local residents from the remains of abandoned log cabins, the Folk Museum at John C. Campbell Folk School houses many tools, artifacts, and handicrafts used in days gone by and is a favorite visiting place for travelers to the school at Brasstown.

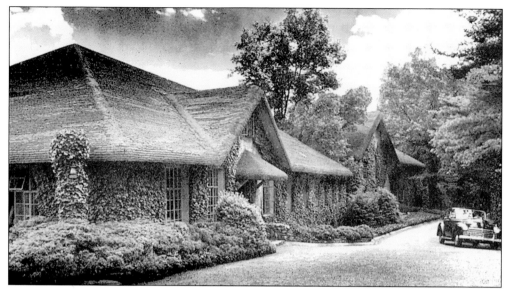

BILTMORE INDUSTRIES. Founded in 1901 by Eleanor P. Vance and Charlotte L. Yale, Biltmore Estate Industries, located in Biltmore Village near Asheville, North Carolina, engaged numerous children and youth in the art of woodcarving. With some support from George and Edith Vanderbilt, Vance and Yale developed a thriving handicraft industry aimed at bettering the lot of local mountain youth. In 1917, George Seely purchased Biltmore Estate Industries. Moving it to the Grove Park Inn in Asheville, Seely renamed the enterprise Biltmore Industries, shifting its focus from woodcarving to weaving. This photograph shows the shops where beautiful homespuns were made. (Hugh Morton Photo.)

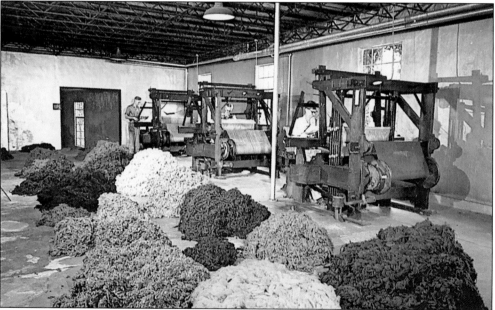

BILTMORE INDUSTRIES HOMESPUN. Hand-operated looms produced colorful wool homespun using traditional materials and methods. The looms and large piles of dyed wool are seen here in the weaving shops at the Grove Park Inn. Except on Sundays and holidays, daily tours were offered to guests at this location.

TRYON TOYMAKERS. Following their establishment of Biltmore Estate Industries in 1901, Eleanor P. Vance and Charlotte L. Yale relocated to Tryon where Tryon Toymakers and Wood Carvers was begun in 1915. Making detailed wood carvings of native wood as well as colorful painted wooden toys, these two women and local mountain children established themselves as skilled artisans whose work was highly desired by tourists and local buyers alike. A custard-colored house with a red roof and green trim, seen here, became both workshop and sales store for the handmade work of Tryon carvers.

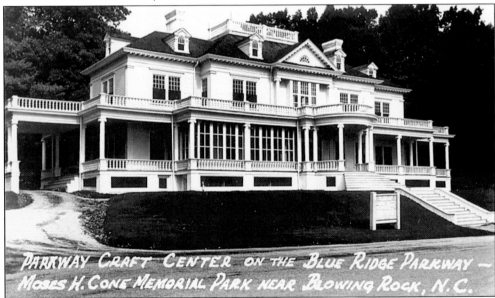

PARKWAY CRAFT CENTER. Once a summer home for the Moses H. Cone family and located along the Blue Ridge Parkway near Blowing Rock, North Carolina (3,586 feet), the house has served for many years as the Parkway Craft Center and is operated by the Southern Highland Handicraft Guild. The guild was organized in 1929. The Cone house with its surrounding meadows and trails is a favorite stop for Blue Ridge Parkway motorists.

PENLAND, THE WEAVING CABIN.
Penland Weavers and Potters was
founded in 1923 as the handicraft
department for the Appalachian
Industrial School. Its founder was Lucy
Morgan. This weaving cabin was built
at the school, near Spruce Pine, North
Carolina (2,620 feet), to aid local
weavers in the development of weaving
techniques and to promote the sale
of their handmade textiles. (Bayard
Wootten photo.)

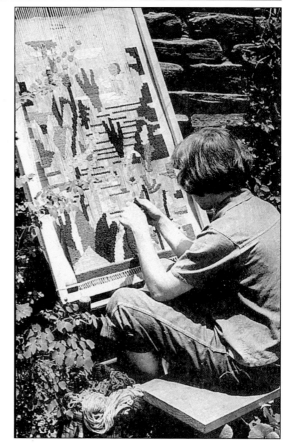

PENLAND, TAPESTRY DESIGN. Although
metalwork and other crafts were taught
and produced at the Penland School of
Handicrafts, textiles were the school's
primary focus. Here, a student works on
a tapestry design.

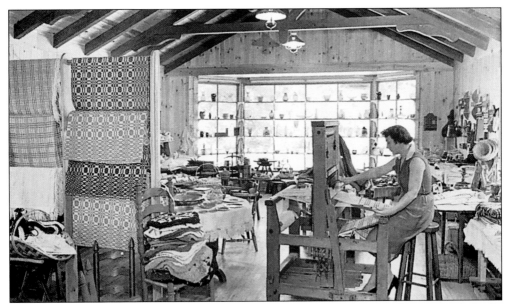

BLOWING ROCK CRAFTS COMPANY. Home of the Goodwin Guild, the Blowing Rock Crafts Company sells handwoven and jacquard-woven reproductions of Colonial coverlets and bedspreads. Goodwin Weavers was founded in 1812.

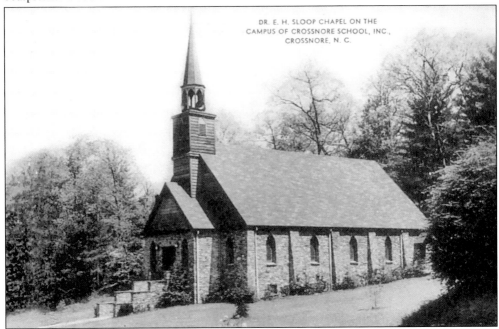

CROSSNORE SCHOOL. Formed in 1913 by doctors Eustace and Mary Martin Sloop, Crossnore School's mission to serve mountain children is legendary. Children whose circumstances prevent them from living at home are welcome at the Crossnore School, where it is believed that "Education is the best way for a child to rise above his circumstances." The Crossnore weaving room was established by Mary Martin Sloop to preserve the traditional craft of weaving and to provide a source of much-needed income for mountain families. This view shows the E.H. Sloop Chapel on the Crossnore School campus. (Asheville Post Card Company.)

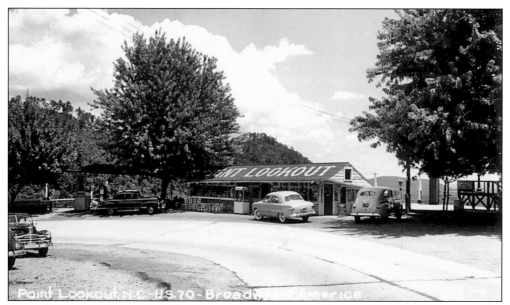

POINT LOOKOUT. A traveler's favorite rest stop, Point Lookout on U.S. Highway 70 offers gasoline, refreshments, crafts and souvenirs, and a magnificent view of Royal Gorge. The route where Point Lookout is located was once part of a central road designed to traverse most of North Carolina. Originally called Highway 10, the portion of this road where Point Lookout is located became part of U.S. Highway 70. This section was bypassed in the early 1950s. (Cline Photo.)

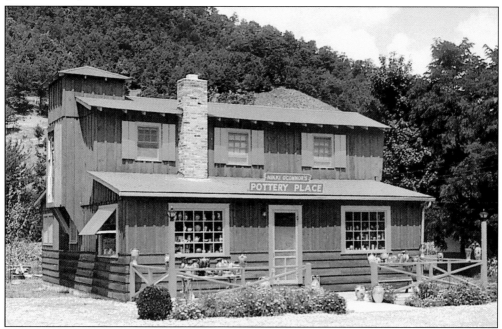

NIKKI O'CONNOR'S POTTERY PLACE. Found on Soco Gap Road in Waynesville (2,635 feet), Nikki O'Connor's Pottery Place features handmade pottery from potters in the Piedmont locales of Sanford and Seagrove, North Carolina. Examples seen in this photograph come from the Cole family of potters, whose ancestors were potters in Staffordshire, England. (Cline Photo.)

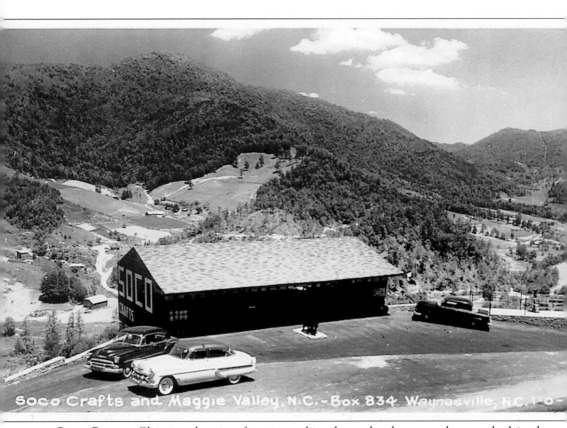

Soco Crafts and Maggie Valley, N.C.—Box 834 Waynesville, N.C. I-0-

SOCO CRAFTS. Claiming the view from its parking lot to be the most photographed in the Smoky Mountains, Soco Crafts has been a mainstay on Highway 19 near Maggie Valley for many years. Near Cherokee Indian Reservation and Ghost Town in the Sky theme park, the craft shop is a souvenir hunter's delight. (Cline Photo.)

Eight

THE CHEROKEE INDIANS

The Iroquois-related Cherokee Indians of North Carolina once lived throughout the mountain region of the state and also in parts of Tennessee, Georgia, South Carolina, and Alabama. Their first contact with Europeans came when Spanish explorer Hernando De Soto, with his entourage of soldiers, slaves, and livestock, came through their land in 1540 in search of gold and other riches. Though often referred to as a reservation, the Cherokee land in North Carolina is not that at all. The Qualla Boundary, a 44,000-acre tract in Jackson and Swain Counties, is land held in trust by the United States for the benefit of the Cherokee people. The Eastern Band of the Cherokee consists of the descendants of the tribe who escaped the "Trail of Tears" removal to Oklahoma Indian Territory in 1838. A Cherokee man named Sequoyah developed an 86-symbol alphabet, or syllabary, allowing the Cherokee to write their language, making them a literate people early in the 19th century. Upon the opening of the Great Smoky Mountains National Park in 1934, the Qualla Boundary and the village of Cherokee became the main entrance into the park for thousands of visitors each year. A thriving Cherokee tourism and handicraft industry followed this momentous event, creating a new source of jobs and income for the native people of the Qualla Boundary. A native craft cooperative was begun, a museum documenting the history of the Cherokee people was created, and Oconaluftee Village, a living museum demonstrating the past ways of the Cherokee, was opened to the public.

CHEROKEE STREET SCENE. The village of Cherokee (1,955 feet) is located within the Cherokee Indian Reservation, known also as the Qualla Boundary, in the Smoky Mountain region of Swain County, North Carolina. Seen in this photo are the Cayuga Trading Post, the Cherokee Scout shop, Cherokee Chieftan Craft Shop, Indian Trading Post, Cherokee Lodge, Reservation Craft Shop, Browning's Craft Shop, Gulf, Esso, and Shell gasoline stations, and several cafes. Two Cherokee men stand dressed in feathered headdresses waiting for tourists to snap their photographs. (Cline Photo.)

CHIEF ARMACHAIN. Shown here in striped pants, silk shirt, and feathered headdress, Chief Armachain poses in front of a teepee at Whitetree's Tourist Center with bow drawn and arrows in hand. This image of the Cherokee, with non-native western Plains Indian teepees and war bonnets, was preferred by tourists whose concept of Indians and Indian life was shaped by their exposure to Hollywood's interpretation of western cowboys and Indians. (Cline Photo.)

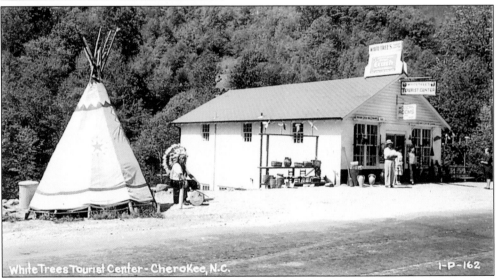

WHITETREE'S TOURIST CENTER. Cherokee's Whitetree's Tourist Center offers modern rooms and a craft shop for its guests. An Indian man, possibly Chief Armachain, sits wearing a headdress by a roadside teepee with bow and arrow and drum nearby. It appears that a woman is prepared to photograph her husband and daughter standing in front of the shop beside a young Indian girl. The shop's outdoor display includes Cherokee baskets, bird whirlygigs, a corn-pounding mortar and pestle, a carved covered wagon and horses, handmade brooms, a feathered headdress, gourds, and handmade North Carolina pottery made by the Cole family of potters. Racks on either side of the door appear to hold postcards or promotional fliers. (Cline Photo.)

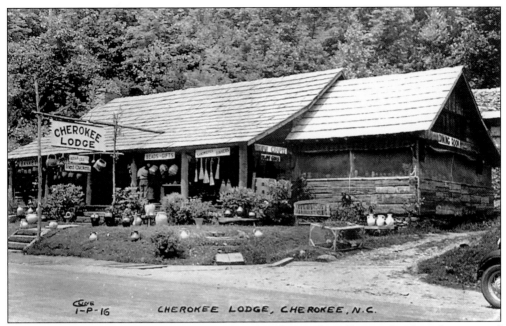

CHEROKEE LODGE. Located in Cherokee, the Cherokee Lodge offers sandwiches, dinners, and fried chicken to its hungry guests. The rustic structure is constructed of hewn log walls, massive porch posts made of native timber, and a wood shingled roof. Its craft offerings include baskets, pottery, beads, blow guns, and other Indian items. (Cline Photo.)

CHEROKEE CHIEFTAN CRAFT SHOP. Located adjacent to the Cherokee Inn and offering Indian and mountain crafts, the stone, log, and ivy-covered Cherokee Chieftan Craft Shop offers the standard fare of tourist souvenir items common to many shops like it in Cherokee and other nearby Smoky Mountain venues. (Cline Photo.)

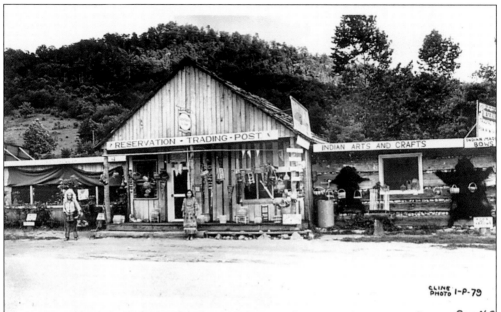

RESERVATION TRADING POST + POW WOW GROUNDS – BETWEEN CHEROKEE + BRYSON CITY, N.C.
STOP HERE FOR INDIAN CRAFTS

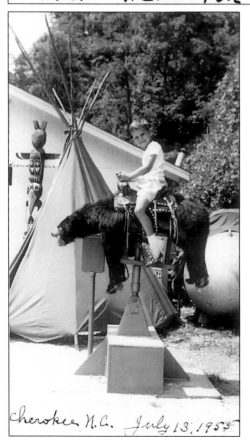

Cherokee, N.C. July 13, 1955

RESERVATION TRADING POST. A Cherokee couple poses outside the Reservation Trading Post and Pow Wow Grounds near Cherokee and Bryson City, North Carolina. This typical tourist craft and souvenir shop displays and offers for sale a variety of items, including baskets, pennants, doll chairs fashioned by mountain craftsmen, gourds, bows and arrows, and pottery. Two native black bear skins adorn the shop's log wall. A sign above the windows on the left wing of the shop boasts, "Best Indian Work in East. U.S.A. Handmade." (Cline Photo.)

BEAR RIDE. This young adventurer enjoys a mechanical bear ride at Cherokee, North Carolina, in July 1955, a noteworthy event not soon to be forgotten.

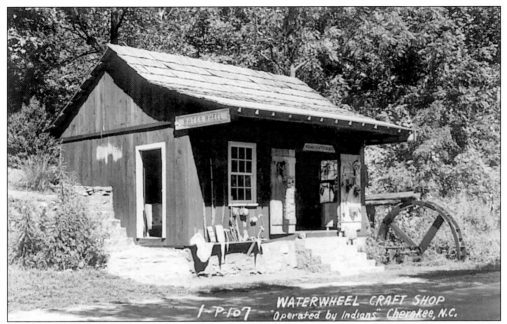

WATERWHEEL CRAFT SHOP. Though fine, handcrafted items were made and sold by Cherokee Indians and vendors who ran craft and souvenir shops in the area, some shops augmented their sales with mass-produced items like brightly painted wooden tomahawks, feather headdresses made of plastic with a few dyed feathers, and tom-tom drums made from cardboard tubes and stretched rubber heads. This view of Cherokee's Waterwheel Craft Shop shows off a nicely made hooked rug draped inside the side door and a more mass-produced lot of items hanging outside for passing tourists to see. (Cline Photo.)

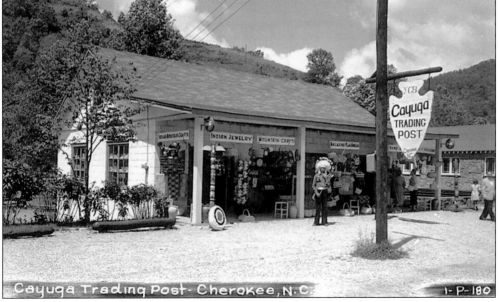

CAYUGA TRADING POST. Boasting 10,000 souvenirs for sale, Cayuga Trading Post offers native baskets, hooked rugs, pottery, Indian and mountain crafts, and other specialty items at its location in the main Cherokee village. (Cline Photo.)

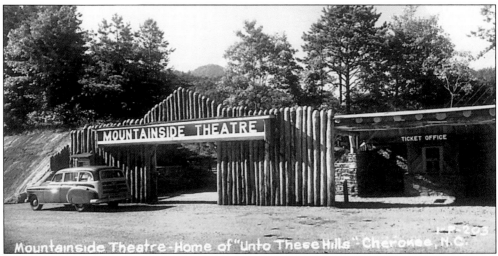

MOUNTAINSIDE THEATRE. Home stage since 1950 for the outdoor drama *Unto These Hills*, the Mountainside Theatre hosts thousands of Cherokee Reservation visitors each year. The theater houses an eternal flame lighted in 1951 from a century-old Cherokee fire maintained in Oklahoma, the terminus of the tragic Trail of Tears march from the Cherokee homeland in 1838. (Cline Photo.)

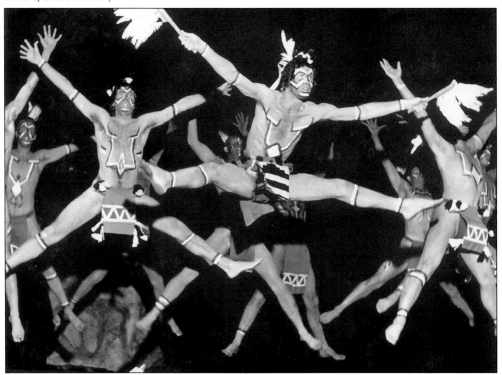

UNTO THESE HILLS DRAMA. Written by Kermit Hunter in 1950, the summer outdoor drama *Unto These Hills* tells the compelling story of the Cherokee Indians, from their encounter with Spanish explorer Hernando De Soto in 1540 through their tragic exile from their Smoky Mountain homeland by way of the infamous Trail of Tears. The Eagle Dance, shown here, is a highlight of the play. More than five million people have seen the play since its 1950 debut.

CHEROKEE BRAVE. This young Cherokee man is dressed in a way, though perhaps not altogether authentic to his own tribal tradition, that portrays how Indians clothed themselves in years past.

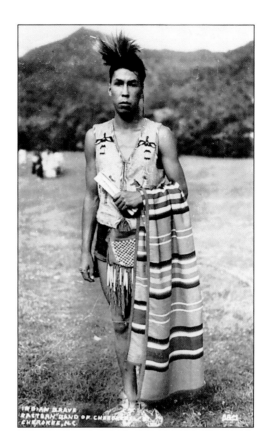

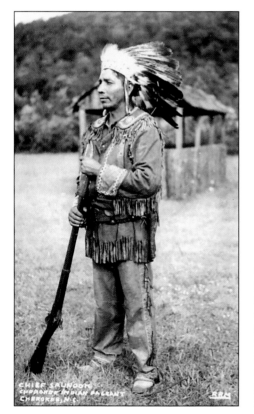

CHIEF SAUNOOK. Dressed in fringed buckskin and a feathered headdress, Chief Saunook seems ready for the hunt or to engage in battle with his enemies. This portrayal of Indian attire was often more appreciated by tourists than traditional Cherokee apparel. Conceding to the demands of the tourism market, many Cherokees dressed this way, satisfying kids and adults alike that they had indeed seen real Indians while visiting western North Carolina.

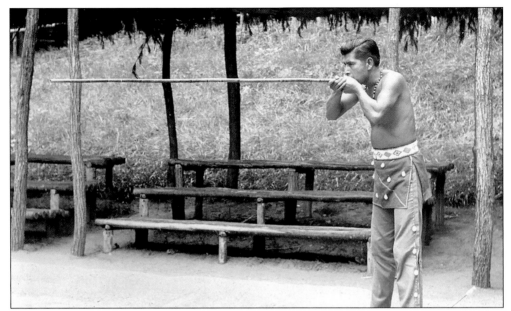

BLOWGUN DEMONSTRATION. The blowgun hunting technique is demonstrated by this Cherokee man at Oconaluftee Indian Village, a re-creation of an 18th-century Cherokee village located and open to the public in Cherokee, North Carolina. Noted for their accuracy when aimed at small game like birds and squirrels, blowguns are made from eight to ten foot lengths of rivercane. Darts, made of locust wood and bull thistle, are blown through the hollowed rivercane at great speed.

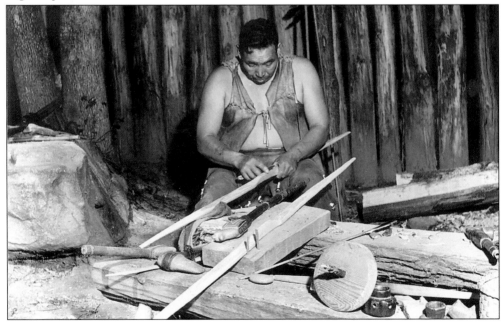

BOW MAKER. This Cherokee bow maker is at work at Oconaluftee Indian Village in Cherokee, North Carolina, showing visitors how this ancient hunting weapon is made. Constructed primarily of locust wood, bows were used to project rivercane-shafted arrows toward their targets. Skilled Cherokee archers often demonstrate to watchful tourists.

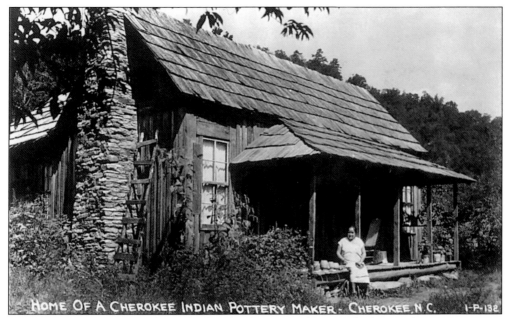

POTTER'S HOME. Here a traditional Cherokee home, in this case the home of a potter, is more reminiscent of the mountain houses occupied by white settlers in the region than traditional native houses. Regardless, travelers flocked by the thousands each summer to view the Cherokee Indians and their environment. (Cline Photo.)

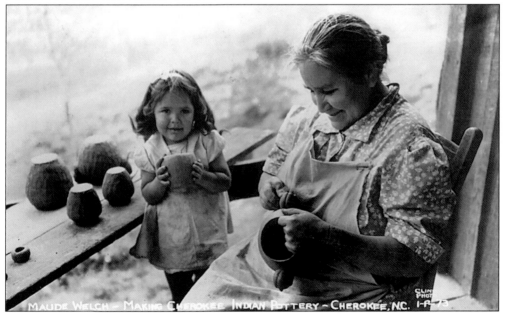

POTTER MAUDE WELCH. Coming from the Birdtown section of the Cherokee Reservation, Maude Welch, born in 1894, was for decades one of the most skilled Cherokee potters. Making wedding jugs, bowls, peace pipes, and many other forms from locally dug clay was Maude Welch's specialty. Her pottery was hand formed without the benefit of a potter's wheel or molds. Using a highly polished stone and small knives for carving decorations into the pieces, this potter created beautiful items for tourists and collectors. (Cline Photo.)

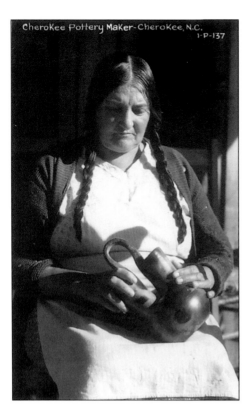

CHEROKEE POTTER. This traditional Cherokee potter holds a double-spouted wedding vase, a favorite of potters and buyers as well. The vase is fashioned after a southwestern Indian vessel pattern, though its unique Cherokee interpretation here is unmistakable. Cherokee pottery is noted for its unglazed and unpainted surface, black and tan color, and smoothly burnished finish. (Cline Photo.)

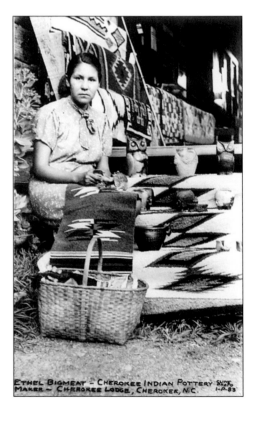

ETHEL BIGMEAT. Shown here on the steps of the Cherokee Lodge in the town of Cherokee, North Carolina, potter Ethel Bigmeat sits surrounded by examples of her handmade work. Sculpted owls, pipe bowls, and vessels featuring carved chief heads wearing headdresses are shown. Ethel Bigmeat represents one of numerous generations of potters in the Bigmeat family.

110

BASKET MAKERS. Young women look on as a skilled Cherokee basket maker weaves a rib basket. Made of white oak, rib baskets are made in several shapes. Some have lids and handles. This form shows the influence white basket makers' shapes and techniques, and a scarcity of rivercane, have had on Indian weavers' basketry. (Cline Photo.)

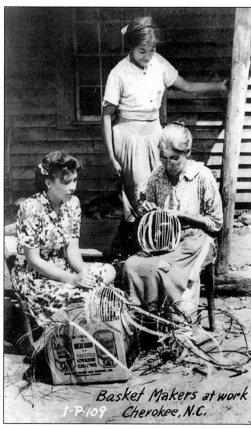

BEAD WORKER. This 1937 photograph shows a pottery and bead worker with a bead loom in hand and numerous pottery vessels surrounding her on the porch and steps of a Cherokee house. The vessel forms seen here are indicative of Catawba Indian pottery, made by another tribe whose homeland is found outside of the mountains on the boundary between North and South Carolina. Early in the 20th century, contact between Cherokee and Catawba potters influenced some of the forms made and techniques utilized by Cherokee potters.

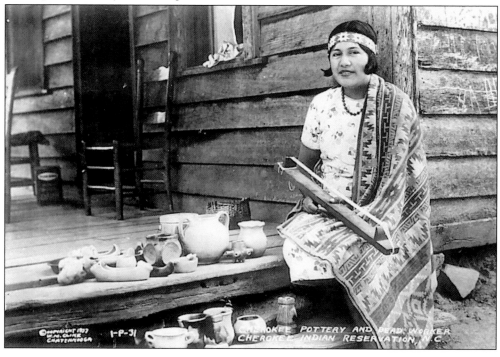

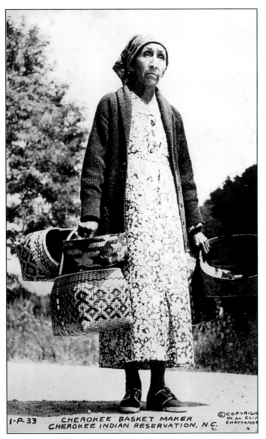

TAKING BASKETS TO MARKET. Rivercane basket weaver Nancy George Bradley is shown here with a beautiful collection of baskets being taken to market for sale or trade. The scarcity of native rivercane caused this form of basket making to become a specialty of just a few women on the Cherokee Reservation. Fortunate tourists and collectors purchased these baskets at tourist craft shops in and around Cherokee. (Cline Photo.)

BASKET MAKERS. Using plain and dyed oak or hickory splints, this mother and daughter pair of basketmakers, Annie Standingdeer and Ollie Tooni, weave these items to be sold to Cherokee Reservation visitors. Photographed in 1931, these women are the wife and daughter of Chief Carl Standingdeer, a skilled archer and favorite snapshot subject of tourists visiting the Cherokee Indian Reservation. (Cline Photo.)

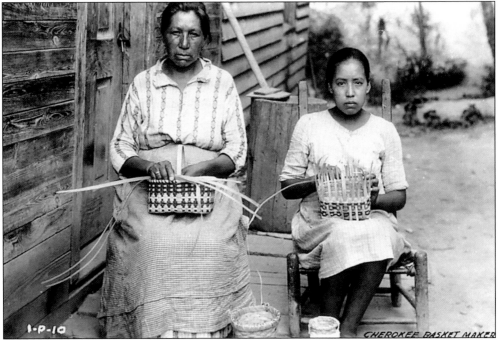

MOSES WALKINGSTICK. Moses Walkingstick demonstrates his archery skill to the photographer on this photo postcard mailed in 1953. Though dressed in an outfit more fitting for an Indian located much farther west in the United States than Cherokee, the bow and arrows are authentic, serving the Cherokee Indians as their primary weapon before the introduction of guns to the area. (Cline Photo.)

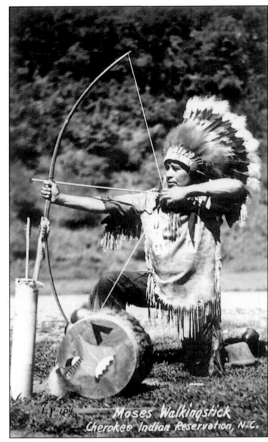

Moses Walkingstick
Cherokee Indian Reservation, N.C.

CHIEF JACK TAYLOR. Shown here at the Big Chief Craft Shop, located between Ela (1,830 feet) and Cherokee, Chief Jack Taylor stands, arms crossed, with stone tomahawk in hand. A tourist stumbling upon this scene need not worry though. It's red paint, not the blood of his latest victim, that coats the ends of his weapon. More tomahawks, rattles, handmade North Carolina art pottery (probably made by the C.C. Cole Pottery in Moore County), whisk brooms, and what appear to be bamboo bull roarers sit and hang from the shelf behind Chief Taylor. (Cline Photo.)

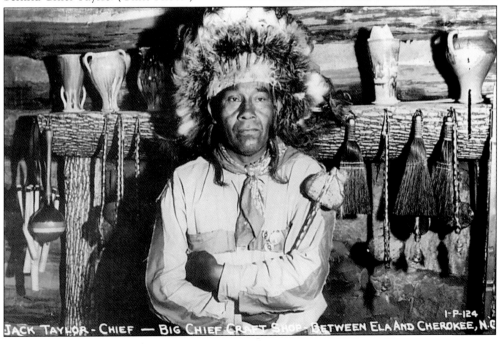

JACK TAYLOR - CHIEF — BIG CHIEF CRAFT SHOP - BETWEEN ELA AND CHEROKEE, N.C.

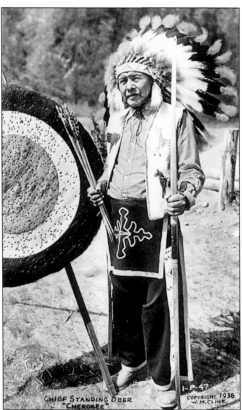

CHIEF STANDINGDEER. Once proclaimed the most photographed Indian in the world, Carl Standingdeer, a Cherokee archer and bow maker, died in 1954 at the age of 74. He posed for thousands of tourist snapshots on the streets of Cherokee. He is seen here in 1938 holding a bow and some arrows. (Cline Photo.)

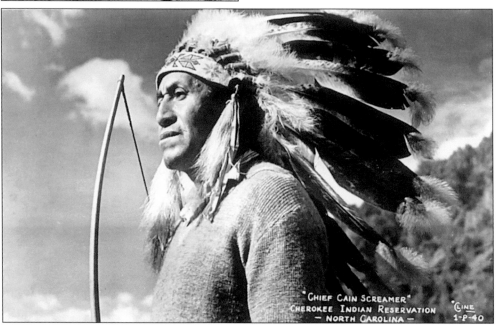

CHIEF CAIN SCREAMER. This outstandingly handsome photograph of a Cherokee man named Chief Cain Screamer skillfully represents the beauty of the people and the land called Cherokee. (Cline Photo.)

114

STEVE SAUNOOK. Standing by a wall made of river rocks, perhaps drawn from the waters of the nearby Oconaluftee River, Steve Saunook is seen here surrounded by large and small art pottery vessels produced by white potters and sold in reservation craft shops to tourists. (Cline Photo.)

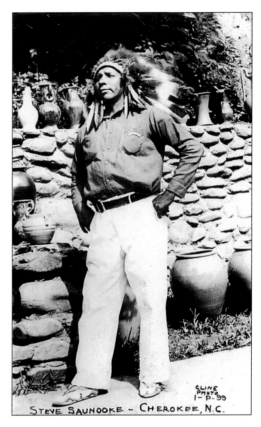

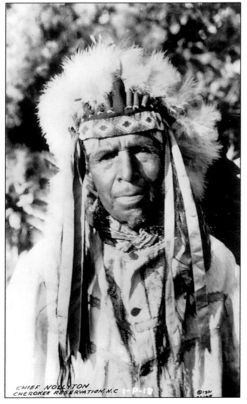

CHIEF NOLLYTON. Chief Nollyton, here bedecked in his beaded and feathered bonnet, handstitched shirt, and bandana, stares plaintively into the photographer's camera. One has to wonder what it is like for a real Indian to play the part of a made up TV Indian, day in and day out, to satisfy snapshot-hungry tourists. In any case, many enterprising Cherokee Indians play to the tourists, and the tourists readily pay to the Cherokee for the privilege of visiting their beautiful mountain reservation.

115

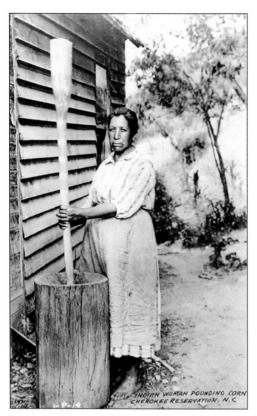

POUNDING CORN. This ancient corn pounding process utilizes a wooden mortar and pestle. The mortar is hollowed out enough to hold about two gallons of corn. The small end of the pestle is rapidly pounded into the corn, creating corn meal. A good pounder can turn a bushel of corn into meal in about half an hour. The woman in this 1931 photograph is Annie Standingdeer, the wife of Chief Carl Standingdeer, noted bowmaker and archer. (Cline Photo.)

GHOST MASK. Following three earthquakes in 1811, that were centered in New Madrid, Missouri, and felt in Cherokee country, a religious revival of sorts occurred among the Cherokee that James Mooney equated with the "Ghost Dance" celebrated by western Indians. Carved wooden disguises, like this Ghost Mask, formerly reserved for use by the Cherokee in rituals and dances, in modern times have been made for sale to tourists. (Cline Photo.)

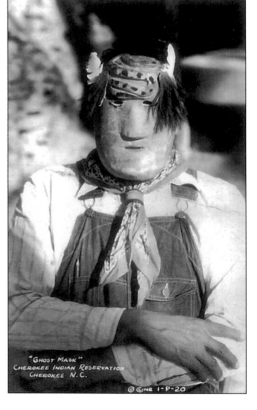

Nine

Dams and Lakes

Lakes constructed for recreation and to encourage development of mountain land dot the landscape of western North Carolina. But the most significant dams and lakes in the region were created by the Tallassee Power Company and the Tennessee Valley Authority (TVA). Tallassee Power Company constructed dams to produce hydro-electric power for use in the production of aluminum by the Aluminum Company of American (Alcoa). The Cheoah Dam was the first built for this purpose by Tapoco (an acronym derived from the name of Tallassee Power Company). Finished in 1918, it stood 225 feet tall, the highest overflow dam in the nation. Santeetlah Dam, located near Robbinsville, at 212 feet high, is another project developed by Tapoco, its waters generating power since 1929. Created as part of Franklin Roosevelt's New Deal program to lift the United States out of the Great Depression, TVA aimed to create jobs and to build water projects for power production, flood control, navigation, recreation, and economic development in the remote areas of the Tennessee Valley drainage area. Western North Carolina is home to numerous TVA dams and lakes, including Apalachia, Fontana, Chatuge, and Hiwassee.

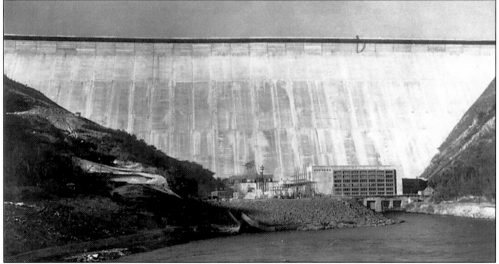

Fontana Dam. Set deep in the Great Smoky Mountains, Fontana Dam is, at 480 feet high, the tallest in the eastern United States. Construction began in 1942 on the massive hydroelectric project created by Fontana Dam. The construction village housed up to 6,000 people at one time. Once abandoned by construction workers, village facilities were adapted to accommodate the thousands of tourists who came to see Fontana Dam and the 30-mile-long lake it formed. (Cline Photo.)

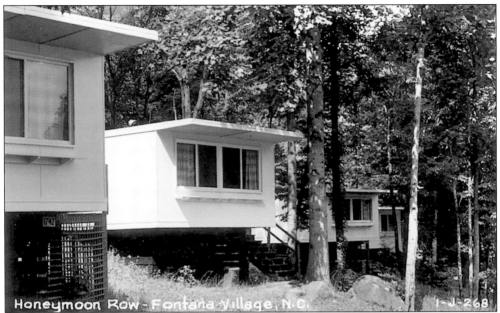

HONEYMOON ROW, FONTANA VILLAGE. Transformed from construction village to vacation resort, Fontana Village (1,800 feet) hosted vacationers in its lodge and some 300 cottages by 1946. The village is located at Welch Cove in Graham County, North Carolina. In addition to its place as a favorite vacation site, Fontana Village quickly became a preferred getaway for honeymoon couples. Seen here is a row of simple cottages called Honeymoon Row. (Cline Photo.)

HONEYMOON COUPLE. Like thousands of others before and after them, these newlyweds chose to spend their honeymoon days and nights inspired by the solitude and beauty of Fontana Village and the Great Smoky Mountains. This photograph, taken in September of 1948, shows my newly married parents, Charlie and Zonie Compton, at an overlook near Fontana Dam.

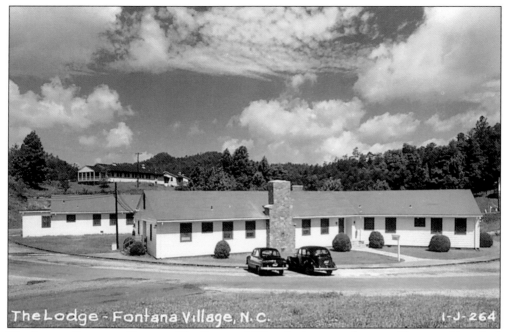

THE LODGE, FONTANA VILLAGE. The Fontana Village Lodge, complemented by several hundred small cottages, provided housing for the first Fontana tourists who journeyed deep into the mountains of western North Carolina for refuge, rest, and adventure. (Cline Photo.)

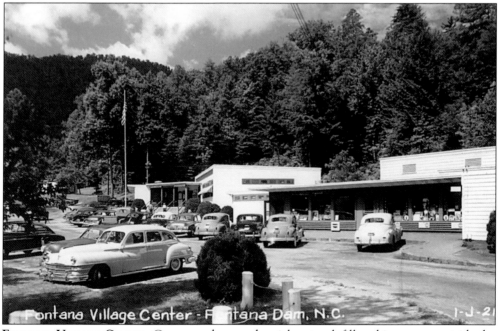

FONTANA VILLAGE CENTER. Coupes, sedans, and a pickup truck fill parking spaces outside the Fontana Village Center. Visitors could shop at the food market, eat at the cafeteria, and buy camping supplies and fishing licenses at the center. (Cline Photo.)

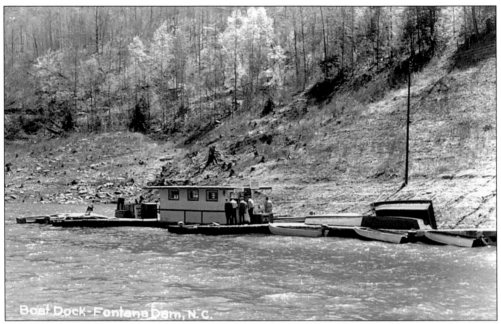

BOAT DOCK, FONTANA DAM. Located on the recently cleared border of Fontana Lake, this boat dock supplied outboard engine boats for fishing and scenic cruising around the 240 miles of lake shoreline. In addition to the production of electricity, Fontana Lake and Dam created an outstanding scenic wonderland for western North Carolina travelers to explore. (Cline Photo.)

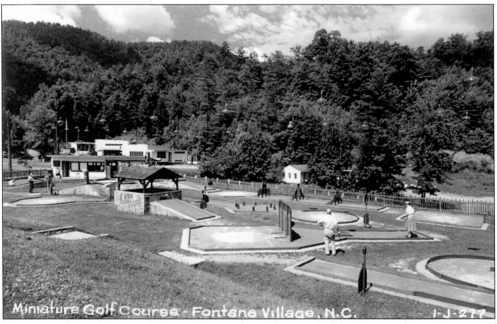

MINIATURE GOLF, FONTANA VILLAGE. Situated near Fontana Village Center, this miniature golf course provided the community's visitors with hours of challenge and pleasure. The shopping center is seen in the background and a cabin is located nearby. (Cline Photo.)

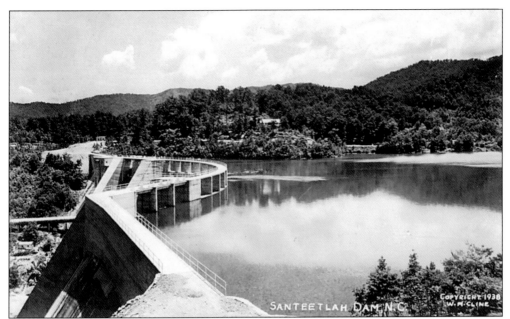

SANTEETLAH DAM. Completed in 1928, Santeetlah Dam created a 2,800-acre reservoir on the Cheoah River in the Nantahala National Forest in Graham County, North Carolina. Built for hydroelectric power production, the 200-foot-high dam is located near the Great Smoky Mountains National Park and the Joyce Kilmer Memorial Forest. (Cline Photo.)

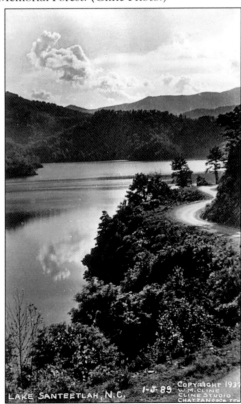

LAKE SANTEETLAH. This 1937 view of Lake Santeetlah displays the natural beauty created when water, sky, and forested mountainsides come together in western North Carolina. The lake is open for boating and fishing, featuring bass, pike, trout, and other kinds of game fish. (Cline Photo.)

121

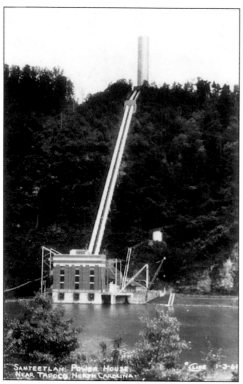

SANTEETLAH POWER HOUSE. Located five miles away from the site of the Santeetlah Dam, the power house is fed by water diverted from the Cheoah River and runs through steel pipe, concrete-lined tunnels and a pair of troughs, called penstocks, about 1,000 feet long. (Cline Photo.)

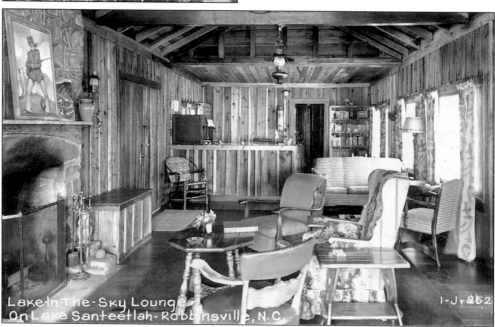

LAKE-IN-THE-SKY LOUNGE, LAKE SANTEETLAH. On land acquired in the mid-1940s from the United States Forest Service, Kenneth Keyes, from Miami, Florida, created a development called Lake in the Sky, which included a small lodge. It is likely that the lounge seen in this photograph is associated with this lodge on Lake Santeetlah near Robbinsville, North Carolina (2,150 feet). (Cline Photo.)

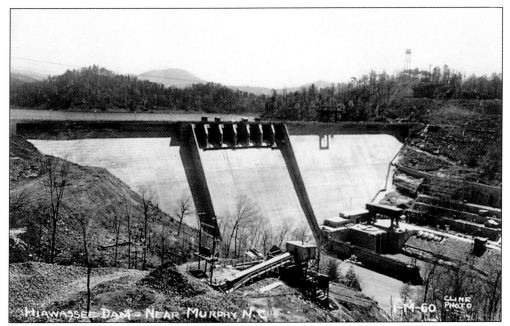

HIWASSEE DAM. Begun in 1936 and completed in 1940, Hiwassee Dam is 307 feet high and 1,376 feet in length where it crosses the Hiwassee River in Cherokee County. One of several western North Carolina dams constructed for the production of hydroelectric power, Hiwassee's power plant is capable of producing 165,600 watts of electricity. (Cline Photo.)

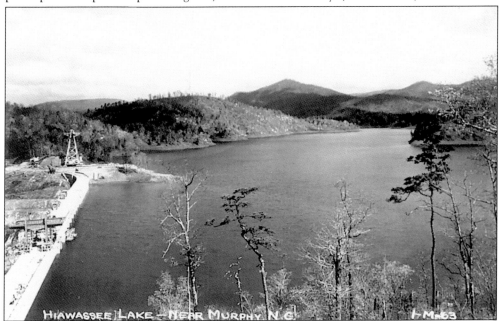

HIWASSEE LAKE. Used for flood control, power generation, and recreation, Hiwassee Lake is formed on the Hiwassee River by the Hiwassee Dam, a Tennessee Valley Authority project completed in 1940. The lake, surrounded by the Nantahala and Cherokee National Forests, covers about 6,120 acres, having a maximum depth of approximately 250 feet. Nearby Murphy (1,535 feet) is one of North Carolina's westernmost towns. (Cline Photo.)

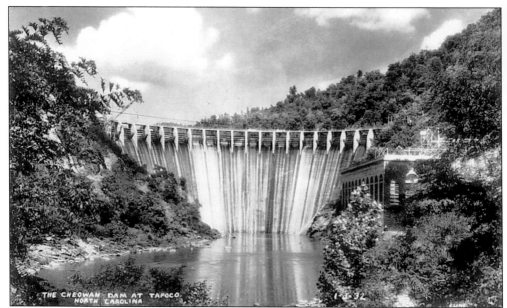

Cheoah Dam. Cheoah Dam, an old mountain dam built in 1919 by Tapoco (Tallassee Power Company), was the first of the company's developments to create electric power to fuel an aluminum plant in Tennessee. Located on the Little Tennessee River, Cheoah Dam impounds the waters of a 615-acre reservoir. The dam is built of hand-cut stone and concrete and at the time of its completion was the highest outflow dam in the world, featuring the world's largest turbines. (Cline Photo.)

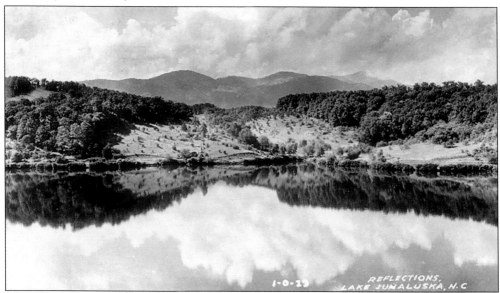

Lake Junaluska. Named for the Cherokee chief Junaluska (1758–1858), Lake Junaluska was built on the former site of the community of Tuscola and, when constructed, covered about 250 acres. The lake is filled by the waters of Haywood County's Richland Creek. A Methodist assembly center and residential resort community, also called Lake Junaluska (2,584 feet), was incorporated about 1909. This 1936 photograph of the shoreline exhibits a rare, undeveloped view of the mountain scenery surrounding Lake Junaluska. (Cline Photo.)

Ten

PLACES MADE
FOR TOURISM

Following World War II, young families, many of whom had moved from rural areas and small towns to new suburban city developments and to employment in factory and retail jobs, found themselves with time off from work called vacation. Ranging from a few days to a few weeks, an employee's vacation gave the opportunity to travel by automobile to recreational venues not usually visited. The so-called baby boom, giving birth to about 75 million children between the years 1946 and 1964, gave impetus to ingenious developers to create vacation destinations catering to young parents and their children. Beginning in the 1960s, western North Carolina's Tweetsie Railroad, Ghost Town in the Sky, and Land of Oz became magnets of tourist activity. Outdoor dramas depicting aspects of the region's history, such as Horn in the West in Boone and Unto These Hills in Cherokee, drew many more people into the region. Unique displays like those seen at Fields of the Wood, with its giant Ten Commandments, Bible, cross, and star of Bethlehem, attracted their own company of visitors. The advent of snow skiing opened the mountains to a clientele not previously accustomed to traveling to the region in wintertime, making the Land of the Sky a truly year round Variety Vacationland.

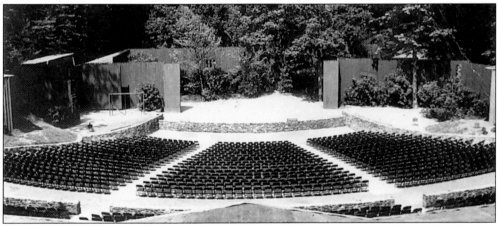

DANIEL BOONE THEATRE. Daniel Boone Theatre, located in the town of Boone (3,333 feet), is home to scriptwriter Kermit Hunter's outdoor drama, *Horn in the West*. Playing to summer audiences for 52 years, *Horn in the West* tells the story of adventurer and North Carolina native Daniel Boone and a band of pioneers who lived in the region during the time of the Revolutionary War. (Cline Photo.)

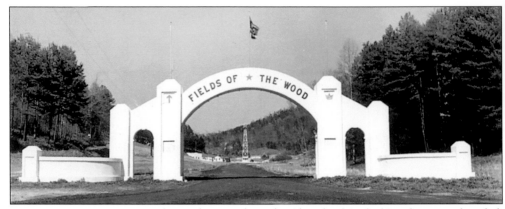

FIELDS OF THE WOOD. Located near the site where the Church of God of Prophecy was founded, near Murphy, North Carolina (1,535 feet), Fields of the Wood is perhaps the most unusual of western North Carolina's tourist sites. Ambrose Jessup Tomlinson, founder of the church, decided that the marking of sacred places would be part of the church's mission. To mark the place where he received a vision to form the new church, Tomlinson decided to create Fields of the Wood. Beginning with a huge version of the Ten Commandments, having letters five feet tall and four feet wide spread across a hillside, Fields of the Wood went on to include the world's largest altar, itself some 80 feet long, a concrete Bible 30 by 50 feet in dimension, a cross 115 feet wide and 150 feet long, a replica of Christ's tomb, and a tower topped by a lighted replica of the star of Bethlehem. (Cline Photo.)

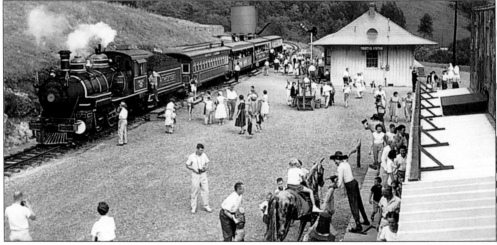

TWEETSIE RAILROAD. Named for the "tweet, tweet" sound of its whistle, the train called Tweetsie is the centerpiece of the Tweetsie Railroad theme park situated between Boone (3,333 feet) and Blowing Rock (3,586 feet). Satisfying visitors since 1957, the park boasts an historic train ride on a three-mile loop track through the Blue Ridge Mountains, complete with Indian raids and cowboy shootouts. In 1881, the East Tennessee & Western North Carolina Railroad Company opened by connecting Johnson City, Tennessee, with iron mines in North Carolina. By 1916, narrow gauge rail service was extended to Boone. After the railroad closed in 1950, engine Number 12, the last of the original 13 coal-fired engines used by the ET&WNC Railroad, was moved to Virginia, then sold to movie star Gene Autry, before being brought back to North Carolina by theme park developer, Grover Robbins Jr., a native of western North Carolina. In this view, old Number 12, now fully restored, stops to pick up passengers at Tweetsie Station. (Hugh Morton Photo.)

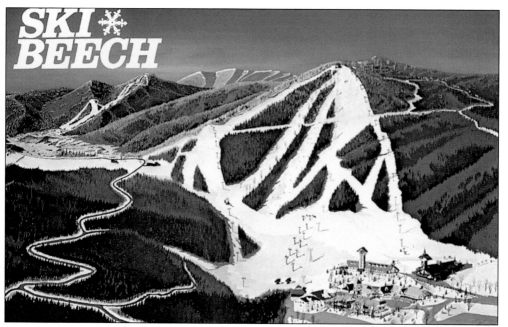

BEECH MOUNTAIN SKI RESORT. Once touted primarily as a summer tourist venue, the mountains of western North Carolina opened up to wintertime travelers with the advent of the first snow-skiing resorts. Cataloochee Ski Resort (opened 1961) says it was the first, but Ski Beech (1967) claims its place as the highest ski resort in Eastern North America (5,506 feet). Both day and night skiing are offered in the short southern winter season, as limited accumulations of natural snow are amplified by the creation of artificial snow made by snow-making machines.

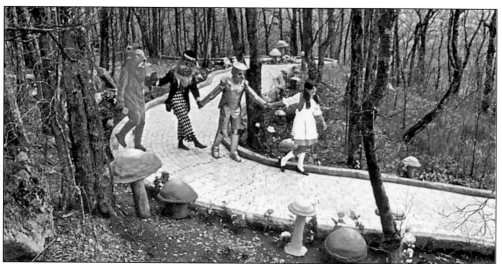

LAND OF OZ. Developed in the late 1960s by Grover and Harry Robbins and designed by Jack Pentes, the Land of Oz theme park attracted over 400,000 people in its first year of operation. Its beautiful natural setting atop Watauga County's Beech Mountain was the site for exciting adventures with the characters of L. Frank Baum's book *The Wonderful Wizard of Oz*. Closed in 1980, props, artifacts, and remnants of the park's yellow brick road can be seen at Boone's Appalachian Cultural Museum.

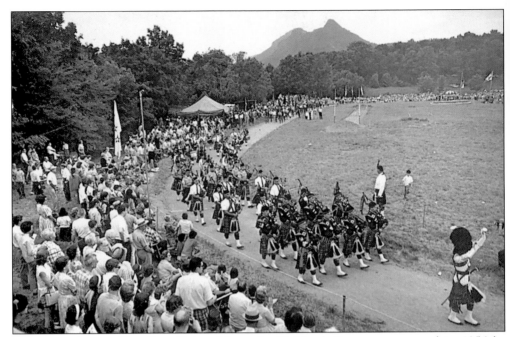

HIGHLAND GAMES. The Grandfather Mountain Highland Games were started in 1956 by co-founders Agnes MacRae Morton and Donald F. MacDonald. The games feature foot-races and other traditional Scottish athletic events, such as tossing the caber and the shotput. This view shows participants led by pipers around the competition field while thousands of onlookers stand ready for the games to begin. The peak of Grandfather Mountain is seen in the background. (Hugh Morton Photo.)

GEM MINING. A delight to seasoned rockhounds and tourists alike, gem mining is a fun and sometimes profitable activity for visitors to the mountains of North Carolina. Gem stones, including rubies, sapphires, garnets, and emeralds, are found at locations where buckets of locally excavated soil and stone are sold to ambitious prospectors. (Jack W. Bowers photo for W.N. Cline Co.)